IMAGES
of America

CENTERS FOR DISEASE
CONTROL AND PREVENTION

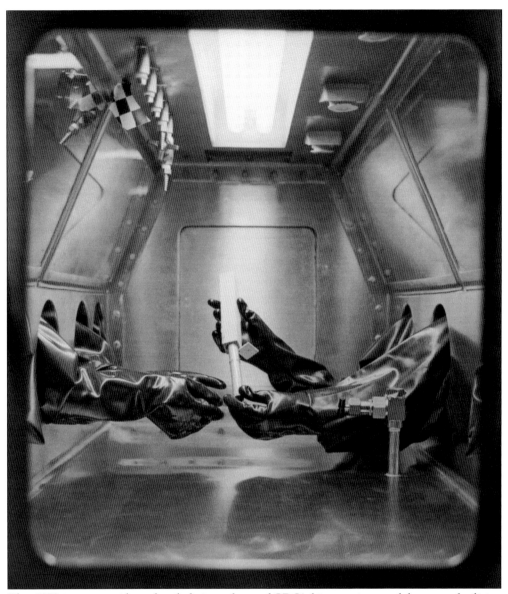

This 1978 image provides a detailed view of one of CDC's biocontainment laboratory facilities. Labs that can safely handle deadly pathogens are usually designated as "BSL-4" (Biosafety Level-4) and are known as maximum containment facilities. Biological safety cabinets and other physical containment devices are used when conducting procedures that have a high probability of generating aerosols. These labs were also referred to as "box labs." (Courtesy of CDC.)

ON THE COVER: In this 1964 photograph, laboratory technicians in one of CDC's tissue-culture media rooms are shown carrying out standard laboratory practices. A close look at the image reveals a shared water still and a small incubator. Modern safety protocols call for lab technicians executing such tasks to wear personal protective equipment (PPE) including safety goggles, gloves, and a face mask. (Courtesy of CDC.)

IMAGES
of America

CENTERS FOR DISEASE CONTROL AND PREVENTION

Bob Kelley
Foreword by Judy M. Gantt, Director, David J. Sencer CDC Museum

ARCADIA
PUBLISHING

Copyright © 2015 by Bob Kelley
ISBN 978-1-4671-1320-5

Published by Arcadia Publishing
Charleston, South Carolina

Printed in the United States of America

Library of Congress Control Number: 2014942733

For all general information, please contact Arcadia Publishing:
Telephone 843-853-2070
Fax 843-853-0044
E-mail sales@arcadiapublishing.com
For customer service and orders:
Toll-Free 1-888-313-2665

Visit us on the Internet at www.arcadiapublishing.com

*To CDC employees in Atlanta and around the world
for your tireless efforts to make our world a safer place*

Contents

FOREWORD

Some people think the Centers for Disease Control and Prevention (CDC) is a mysterious place that only investigates rare or never-before-seen diseases. CDC scientists do indeed crack the cases of mystery diseases using old-fashioned detective work with high-tech science, but there is so much more! The history of CDC is the history of dedicated individuals who work to make a difference in the health of people almost everywhere around the world. Often working behind the scenes, we are the nation's protection agency—saving lives, protecting people from health threats, and saving money through prevention.

With this book, Bob Kelley is opening the doors through photographs and brief vignettes about CDC's important work. The history of CDC corresponds with much of the history of public health, and the hope is that the breadth and depth of the work will both surprise and enlighten.

As you will see, CDC works around the clock to keep America safe from health, safety, and security threats—both foreign and domestic. Whether diseases start at home or abroad, are chronic or acute, curable or preventable, or due to natural disasters or deliberate attacks, CDC fights diseases and supports communities and citizens to do the same. We save lives from infectious diseases, harmful environmental hazards, injuries, and emergencies by providing emergency response, expertise, strengthening public health infrastructure, developing and deploying vaccines, and improving disease detection globally.

CDC's story includes fascinating mysteries resolved, challenges overcome, and practical problem solving that ranges from finding the cause of Legionnaires' disease to using a ring immunization strategy around smallpox to stop transmission and to better manage vaccine in the event of an outbreak; from recommending that women take B-vitamin folic acid prior to pregnancy to prevent neural tube defects to finding that taking lead out of gasoline decreased the amount of lead in people's blood.

The work continues, and people around the world are safer and healthier because of CDC.

Judy M. Gantt
Director, David J. Sencer CDC Museum

ACKNOWLEDGMENTS

A year and a half ago, when I wrote a feature article for a local newspaper on the David J. Sencer CDC Museum, little did I realize the effort would lead to writing this book. Until that moment, all I really knew about CDC was that it was an important government agency with a name that surfaced every time a major public health issue made headlines or was featured on the evening news. Not until I started writing this book did I really understand the role that CDC plays in our everyday lives.

When I approached Judy M. Gantt, director of the David J. Sencer CDC Museum, about writing the book, she was immediately on board. So were Mary Hilpertshauser, the museum's historic collections manager, and Louise E. Shaw, the museum's curator. Without them, this book would not have been possible. Their guidance through various CDC-related photograph libraries was invaluable in helping me navigate the sea of historical photographs relevant to CDC's past and present. In fact, all images in this book are courtesy of CDC, unless otherwise noted. Also, thank you to Brittany Behm, of CDC News Media, who provided initial input into the project and was always willing to provide any additional assistance.

Another invaluable source in this project was Douglas R. Atkins, library technician at the National Library of Medicine at the National Institutes of Health (NIH). Doug quickly responded to every inquiry and provided pre-CDC historical photographs from the library's archives; he could not have been more accommodating.

I also wish to thank my editor at Arcadia, Liz Gurley. There were many times when I needed her to nudge me toward the finish line, and she was always there to do so in a gracious way. Also, a thanks goes to Beth Steiner and Bryan Humphrey at the Moore Memorial Public Library in Texas City, Texas, for the Texas City photographs. Texas City was the site of a horrible explosion in 1947, and this disaster marked the first time CDC was asked to be a "first responder." Thanks also to Jennifer Hallaman and Emily Staub at The Carter Center for securing approval for the use of photographs provided by the center.

I would also like to thank Elizabeth W. Etheridge, author of the 1992 book *Sentinel For Health: A History of the Centers for Disease Control*. The information in her book provided guidance for much of my CDC research and treasure hunt for photographs.

And, finally, thank you to Ed St. Amour, my personal "copy editor," and all of my family and friends for their support and enthusiasm over the past year.

INTRODUCTION

For nearly 70 years, the Centers for Disease Control and Prevention (CDC) has been at the forefront of protecting the United States—and the world—from threats to public health such as infectious and chronic diseases, injuries, workplace hazards, disabilities, and environmental health issues. Not only has it been a leader in assisting with public health challenges, its elite scientists, epidemiologists, researchers, surveillance teams, doctors, and public health advisors have taught local staff members in communities, states, territories, and countries worldwide to carry on its work long after CDC's public health professionals have packed their equipment and returned home.

Organized on July 1, 1946, CDC evolved from a World War II agency, the Office of Malaria Control in War Areas (MCWA), a program within the US Public Health Service (PHS). Established in 1942, MCWA's primary job was malaria control and prevention in areas around military bases and industrial sites tasked with production related to World War II. These "war areas" were primarily located in 15 southeastern states, Puerto Rico, the Virgin Islands, and Caribbean areas related to the United States. Once World War II was over, the federal government converted MCWA operations from war-related efforts to addressing more general communicable disease problems that affect the nation as a whole, and MCWA became the Communicable Disease Center (CDC), with headquarters in Atlanta, Georgia. It is fitting that CDC emerged from a wartime effort, because from its inception, it has been waging war against the world's gravest health threats and medical mysteries.

A brief glimpse at the nation's public health landscape prior to the creation of CDC may offer added appreciation for the agency's stunning accomplishments over the years.

When the country's founders formed the United States, the 13 original colonies were primarily seaports on the Atlantic Coast with outlying small towns inland. The colonies had local sanitation laws and were keenly aware of diseases being carried on ships sailing to the New World. Even after the formal creation of the United States, public health was not addressed by the government; the US Constitution makes no mention of it. However, following a yellow fever epidemic in 1798, Pres. John Adams signed the first federal public health law, which created the Marine Hospital Service (MHS) for merchant seamen—a forerunner of the modern PHS. This law imposed a monthly hospital tax of 20¢ that was deducted from the pay of merchant seamen for the care of sick seamen and the building of independently operated Marine hospitals. An amending act to the legislation of 1798 extended MHS benefits to officers and enlisted men of the US Navy. MHS was also responsible for the medical inspection of immigrants, the supervision of national quarantine, and prevention and control of the interstate spread of diseases such as yellow fever, cholera, and smallpox.

Throughout the 18th and 19th centuries, diseases ran rampant due to poor sanitation and the limited availability of doctors. Most family illnesses were treated at home using homemade herbal remedies. Often, if no cause for an epidemic was known, people simply waited until it had run its course. Although "doctors" were officially recognized in 1769, they were only educated to take care of broken bones and to prescribe herbs and hard liquor that would vanquish evil spirits. Few doctors had any formal training; most learned from other physicians in an informal setting.

In 1902, Congress enacted a bill to increase the efficiency and change the name of the Marine Hospital Service to the Public Health and Marine Hospital Service. The law authorized the establishment of specified administrative divisions and, for the first time, designated a bureau of the federal government as an agency in which public health matters could be coordinated. In 1912, it simply became the US Public Health Service, broadening the PHS research program to include "disease of man" and contributing factors such as pollution of navigable streams and information dissemination. By the early 20th century, some progress had been made in treating

communicable diseases, but epidemics—such as the plague that hit San Francisco in the early 1900s and the global Spanish influenza epidemic in 1918 and 1919—showed that despite PHS efforts, there was still much to be done to address health emergencies.

When CDC was created in 1946, the fledgling program had an ambitious agenda, but with a core staff of only 430 and a budget of $1.6 million, it faced formidable challenges. Dr. Joseph Mountin, a visionary leader in the PHS, hoped to expand CDC's interests to include all communicable diseases and to provide guidance and practical help to all entities associated with the United States. World-class scientists soon began filling CDC's laboratories, and many states and foreign countries sent staff members to Atlanta for training. Although the new agency was making headway in the prevention and control of malaria, typhus, and yellow fever, Dr. Mountin was not satisfied with this progress and impatiently pushed the staff to do more. He reminded them that CDC was responsible for any communicable disease. To survive, it had to become a center for epidemiology.

In 1949, Dr. Alexander Langmuir came to CDC to head the epidemiology division. He quickly organized a disease surveillance system that would ultimately become the cornerstone of CDC. The threat of biological warfare that loomed after the outbreak of the Korean War in 1950 led to the organization of CDC's Epidemic Intelligence Service (EIS). EIS officers were charged with guarding against ordinary threats to public health while simultaneously watching for new and emerging infectious diseases.

The first class of EIS officers began work in 1951, pledging to go wherever they were needed over the following two years. They quickly became known as "disease detectives." Using "shoe-leather epidemiology," they traveled door-to-door in areas suffering from a disease outbreak to gather surveillance data, literally making house calls around the world. There were 23 recruits in the first EIS class: 22 physicians and one sanitary engineer. Today, classes of around 80 EIS officers are given two-year assignments domestically and internationally. Classes are composed of medical doctors, veterinarians, nurses, researchers, dentists, and scientists. In addition to working with CDC public health advisors in global disease "hot spots," the majority of EIS graduates work with state and local health departments to address a broad spectrum of health challenges including chronic disease, injury prevention, violence, environmental health, occupational safety and health, and maternal and child health, as well as infectious diseases.

Two major health crises in the 1950s helped to establish CDC's credibility and reputation. A surge of poliomyelitis cases in the 1950s created a nationwide panic as state and local health departments were tasked with administering a national project to vaccinate thousands of children and adults across the country. When polio appeared in children following inoculation with the Salk vaccine, EIS officers helped identify the problem as stemming from a distributor of the vaccine. In 1957, when the United States was faced with the huge Asian flu pandemic, EIS teams gathered data and developed national guidelines for an influenza vaccine. In this era, CDC contributions to coordinating immunization campaigns and involvement in other public health–related projects began to give the nation and the world a glimpse of its real potential.

In the late 1950s and 1960s, CDC grew even larger with the addition of the venereal disease program (1957), the tuberculosis program (1960), and the Foreign Quarantine Service (1967)—one of the oldest and most prestigious units of the PHS. In 1961, the National Office of Vital Statistics was moved to Atlanta, and CDC began publishing the *Morbidity and Mortality Weekly Report*. Each issue of this report contained accurate, timely scientific information about the most recent outbreaks, investigations, and public health recommendations. To this day, this unique publication has never missed its weekly deadline. In the late 1960s, CDC worked closely with the National Aeronautics and Space Administration (NASA) to protect the earth from germs that could potentially be brought back from outer space by returning Apollo astronauts and, conversely, preventing harmful earth germs from being carried into outer space.

The establishment of the smallpox surveillance unit in 1963 would give CDC one of its greatest achievements in public health: the eradication of smallpox. By refining mass vaccination techniques using the Ped-o-Jet, an instrument refined by the US Army for CDC use, and working in tandem

with other global health agencies to create a successful "surveillance and containment" strategy, the smallpox virus was eradicated from the world by 1980.

In 1970, CDC was renamed the Center for Disease Control by the federal government to denote its expanding presence in matters related to public health. During this decade, CDC, while maintaining its role in fighting infectious diseases, was also becoming a principal prevention arm of the federal government. Soon, it became involved in a wide array of public health programs dealing with chronic disease and injury control, family planning, and health-related aspects of human lifestyles and community environments. Efforts to improve occupational environments were given a boost when the National Institute for Occupation Safety and Health (NIOSH) joined the ranks of CDC. Watershed events in the 1970s included the outbreak of the mysterious Legionnaires' disease and the first outbreak of Ebola in Africa. CDC surveillance and research helped address both emergencies.

During the 1980s, newly emerging infectious diseases would become the focus for many CDC researchers and epidemiologists. AIDS appeared out of nowhere to become a premier health threat; CDC provided leadership for the first task force to address the issue and continues to help in the fight against this deadly disease. CDC also helped with the Atlanta Child Murders investigation in the early 1980s. Known as the "missing and murdered children case," this tragic crime involved a series or murders committed in Atlanta, Georgia, from the summer of 1979 until the spring of 1981. Over the two-year period, at least 28 African American children, adolescents, and adults were killed. CDC provided assistance by utilizing epidemiological detective work to investigate the risk factors the victims had in common. CDC participation in this investigation led to the creation of CDC's Violence Epidemiology Branch in 1983, now the Division of Violence Prevention.

The CDC merged the disciplines of health economics and decision science in the 1990s to create a new area of emphasis: prevention effectiveness. Other contributions to worldwide health issues during this decade included participation in the global polio eradication campaign and expanded research in prenatal care that aimed to improve infant health by reducing instances of appalling birth defects such as spina bifida and anencephaly.

At the dawn of the 21st century, the challenges kept coming, and CDC kept stepping up to the plate. The perceived global electronic disaster of Y2K and the actual disaster on September 11, 2001, at the World Trade Center and Pentagon required assistance from CDC. Natural disaster response, a part of CDC tradition since the 1940s, has also kept the agency staff involved as first responders during national and international catastrophes.

The agency's name was changed by Congress one final time in 1992 to Centers for Disease Control and Prevention, and as of today, CDC is part of the US Department of Health and Human Services. It has grown to include over 15 centers plus numerous offices and branches.

Since 1946, CDC has utilized scientific and epidemiological expertise to help people around the world enjoy healthier, safer, longer lives. It is recognized today for its scientific research, investigations, and application of its findings to improve people's daily lives and to respond to health emergencies—something that sets CDC apart from its peer agencies. As CDC moves forward in the 21st century, it has five strategic areas of focus: providing support to state and local health departments, continuing to look for ways to improve global health, implementing measures to decrease leading causes of death, strengthening surveillance and epidemiology, and endeavoring to reform health policies.

Today, with a budget of $8 billion and a workforce of approximately 15,000 people, CDC is recognized as one of the premier public health agencies in the world. It is constantly evolving to handle health threats and emergencies and to make day-to-day living as healthy as possible for populations around the world.

One

Before CDC
America's First Health Responders

An old adage says that "where we came from is part of who we are." Although it was not established until 1946, CDC, as a part of the US Public Health Service, had deep roots in public health and disease control measures dating to the founding of the United States.

The colonists had a rough time of it when it came to surviving prevalent health issues of the day. With unsanitary conditions and disease brought from Europe, it is a wonder America grew and prospered at all. It did not take long for the colonists to recognize that disease most often arrived via foreign ships and sailors, so public health and maritime health have been joined since the country's earliest history.

"Old country" contagious diseases like yellow fever, plague, cholera, syphilis, and measles—all of which CDC would one day help control or prevent—were some of the most dreaded diseases of the day. A particularly harsh yellow fever epidemic hit Philadelphia in 1793 and killed nine percent of the city's population. On July 16, 1798, Pres. John Adams signed the Act for the Relief of Sick and Disabled Seamen, which created the Marine Hospital Fund, the first publicly funded health care and disease prevention federal agency in the United States. The Marine Hospital Service (MHS), established in 1870, emerged from this act.

In 1878, as the nation grew, the scope of the MHS expanded to include domestic and foreign quarantine and other national public health functions, as well as the creation of a vast network of Marine hospitals. The prevalence of major epidemic diseases spurred Congress to enact the National Quarantine Act to prevent the introduction of contagious and infectious diseases into the United States. The task of enforcing the act fell to the MHS. By 1902, the agency's name was changed by the federal government to the US Public Health and Marine Hospital Service, and a final name change in 1912 shortened the agency's official title to US Public Health Service.

While the agency made critical strides in improving the nation's health, there was still much to be done to combat infectious diseases around the world. Major epidemics of the era included two bubonic plagues in San Francisco between 1900 and 1909 and the Spanish influenza pandemic of 1918 and 1919, a global disaster that killed up to 50 million people.

A Brief Rule to guide the Common People of *New-England* how to Order themselves and theirs in the *Small-Pox* and *Meafels*.

THE *Small Pox* (whofe nature and cure the *Meafels* follow) is a difeafe in the blood, endeavouring to recover a new form and ftate.

2. THIS nature attempts — 1. By Separation of the impure from the pure, thrufting it out from the Veins to the Flefh.— 2. By driving out the impure from the Flefh to the Skin.

3. THE firft Separation is done in the firft four Days by a Feverifh boiling(Ebullition)- of the Blood, laying down the impurities in the Flefhy parts which kindly effected the Feverifh tumult is calmed.

4. THE fecond Separation from the Flefh to the Skin, or *Superficies* is done through the reft of the time of the difeafe,

In the colonies, numerous health issues and diseases ran rampant due to poor sanitation and a lack of doctors. This 1721 Boston newspaper notice offered a guide to the common people of New England about how to take the first steps in treating the onset of measles and smallpox, two preeminent diseases of the day. (National Library of Medicine.)

In 1870, Pres. Ulysses S. Grant established the Bureau of the US Marine Hospital Service (MHS). The new bureau's official seal, designed by Dr. John Maynard Woodworth, featured a caduceus crossed with a fouled anchor. A fouled anchor represents a seaman or boatman in distress. The caduceus is the symbol of Hermes, the Greek god of commerce and trade. (National Library of Medicine.)

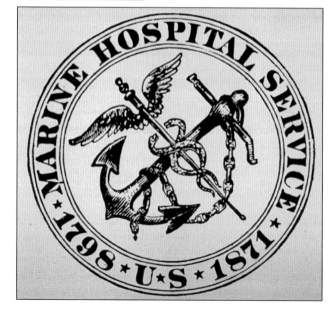

In 1871, Dr. John Maynard Woodworth was appointed as the first US Marine Hospital Service (MHS) Supervising Surgeon, a forerunner of the modern Surgeon General of the United States. A Civil War veteran, Woodworth adopted a military model for his medical staff and required physicians to wear uniforms. In 1889, Pres. Grover Cleveland created the Public Health Service Commissioned Corps, a uniformed component to the MHS. (National Library of Medicine.)

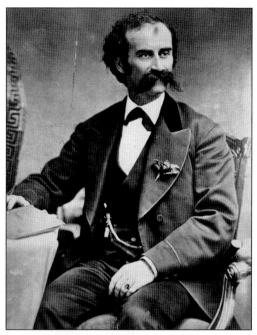

This 1924 image shows Public Health Service Commissioned Corps (PHSCC) officers in dress uniform at the US Marine Hospital in New Orleans. The PHSCC is one of only seven uniformed services of the United States. Initially open only to physicians, the corps expanded to include dentists, engineers, pharmacists, nurses, environmental health specialists, scientists, and other health professionals over the course of the 20th century. (National Library of Medicine.)

The Marine Hospital Service (MHS) established Camp E.A. Perry, a detention camp, on the border between Georgia and Florida during a yellow fever epidemic in 1888. During the spring and summer of that year, there were a number of yellow fever outbreaks in the Gulf States. The MHS helped state and local health authorities control its spread by setting up this and similar camps. People traveling from areas stricken with yellow fever were required to stay in the camp for the incubation period (six to ten days) before proceeding elsewhere. This camp was named in honor of E.A. Perry, governor of Florida, who assisted in establishing and maintaining it. Yellow fever (also known as yellow jack or yellow plague), an acute viral disease with origins tracing to Africa, was one of the most dangerous infectious diseases in the western hemisphere in the 18th and 19th centuries. (National Library of Medicine.)

Dr. Joseph Goldberger was a pioneering epidemiologist who joined the Marine Hospital Service in 1899. He initially conducted health inspections of new immigrants at Ellis Island and later became involved in efforts to combat yellow fever, typhus, dengue fever, and typhoid fever. He is best known for his research on pellagra, a disease that causes skin rashes, mouth sores, diarrhea, and—if untreated—mental deterioration. Dr. Goldberger's observations ultimately showed that the problem was not infectious but nutritional.

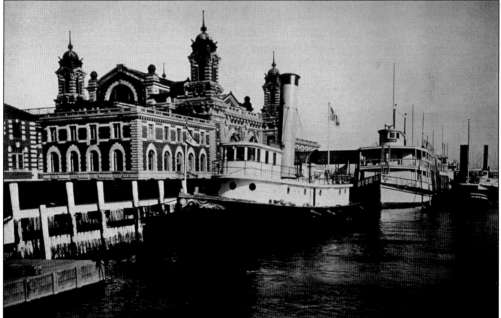

The 1891 Immigration Act required that all immigrants coming into the United States be given a health inspection by Marine Hospital Service physicians, usually at the Ellis Island inspection center in New York (shown here) or at Angel Island in San Francisco Bay. This act declared that certain classes of individuals were unfit to become American citizens. It specified the expulsion of "all idiots, insane persons, paupers or persons likely to become public charges, persons suffering from a loathsome or dangerous contagious disease, and criminals." If physicians found any diseases, they immediately put the individuals into quarantine or sent them back to their country of origin. (National Library of Medicine.)

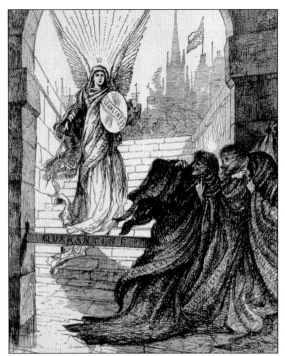

An 1885 wood engraving from *Harper's Weekly* shows how public health issues were often elaborately dramatized by the media in the 19th century. Depicting disease in metaphorical terms, the shrouded and skeletal specters representing cholera, yellow fever, and smallpox recoil in fear as an angel holding a sword and shield emblazoned with the word "cleanliness" blocks their way through the quarantine barrier at the Port of New York. (National Library of Medicine.)

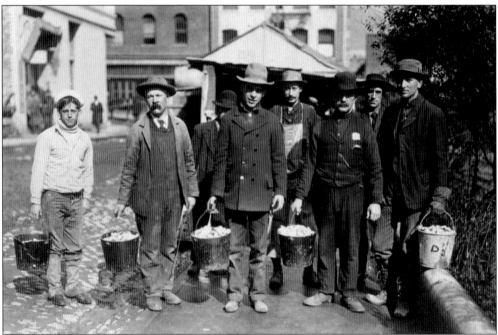

In the first years of the 20th century, the Marine Hospital Service (MHS) created a "War on Rats" in San Francisco to combat one of America's first recorded bubonic plagues. The outbreak originated from rats and infected passengers on cargo ships that arrived in San Francisco in 1900. The 1906 earthquake in San Francisco encouraged a second outbreak of the epidemic as thousands of rats lost their homes, making the city highly conducive to rat and flea infestation. These MHS workers are holding buckets filled with rat bait. (National Library of Medicine.)

This 1920 photograph shows three malaria control health workers in the process of using dynamite to remove tree stumps in Virginia. Note that the seated man is holding three sticks of dynamite. This common practice was used to create proper drainage ditches to alleviate standing water in which the larvae of malaria vectors could reside.

A Sisters of Charity nurse conducts blood tests at the infirmary at the National Leprosarium in Carville, Louisiana. The sisters volunteered to nurse the sufferers of leprosy who sought help at the leprosarium. The Carville facility, located between Baton Rouge and New Orleans, promoted the understanding, identification, and treatment of leprosy, also known as Hansen's disease. In 1921, the Public Health Service took control of the facility, and it became US Marine Hospital Number 66.

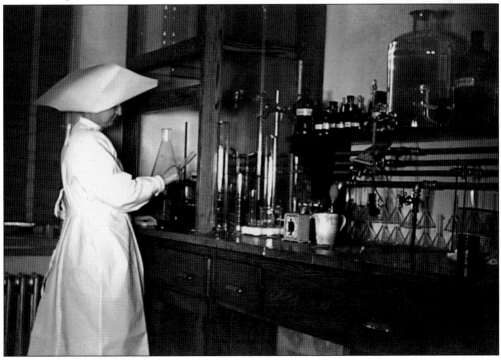

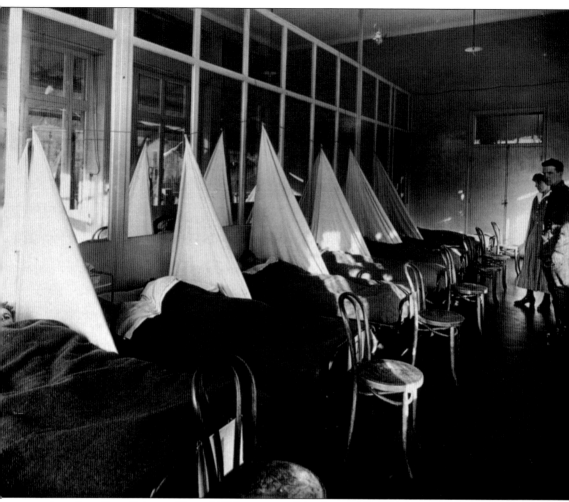

American Expeditionary Force (AEF) victims of the Spanish flu pandemic are pictured at a US Army camp hospital in Aix-les-Bains, France, in 1918. The Spanish flu pandemic was one of the most devastating epidemics in recorded history, killing 20 to 50 million people worldwide. By comparison, 16 million people died in World War I. In America, 25 percent of all citizens were infected, and more than 500,000 died. The influenza pandemic took the lives of more than 25,000 men from the AEF, while another 360,000 became gravely ill. (National Library of Medicine.)

Two

THE 1940S
THE BATTLE AGAINST MALARIA GIVES RISE TO CDC

Of all the diseases transmitted to humans by insects and animals, malaria was one of the most serious threats to civilian and military health during World War II. Malaria Control in War Areas (MCWA), a wartime agency created in 1942 under the auspices of the US Public Health Service (PHS), worked to control malaria around military bases in the southern United States and in US territories.

The PHS placed Dr. Louis L. Williams Jr., its chief specialist in mosquito-borne diseases, in charge of MCWA. Working with state and local health departments, MCWA set up mile-deep mosquito-free zones around each military base. (A mile is the flight range of *Anopheles quadrimaculatus*, the breed of mosquito that transmits malaria.)

The basic plan was to form control teams of physicians, engineers, and entomologists to locate infected humans, determine the prevalence of mosquitoes, find breeding places, and apply control measures. The introduction of DDT, an insecticide, in 1944 drastically helped in the fight. Mixing DDT with water formed a spray that could retain its insecticidal property for long periods of time.

As a wartime agency, MCWA met new challenges in a way that demonstrated the efficiency of attacking related health problems with teams of specialists whose activities were coordinated within a single organization—the basic premise of the soon-to-be-created CDC, a peacetime health agency with a much broader purpose.

On July 1, 1946, the Communicable Disease Center, as CDC was first known, was created by the federal government and based in Atlanta. It was the result of the vision of Dr. Joseph Mountin, chief of the Bureau of State Services for the PHS, and other PHS leaders who recognized that MCWA's success in malaria control could become the foundation for improving the health of the nation.

The National Malaria Eradication Program, focused on eliminating malaria throughout the United States, began in 1945. This program consisted of partnerships with state and local health agencies in 13 Southeastern states. In 1947, about 15,000 malaria cases were reported, and known cases had dropped to only 2,000 in 1950. By 1951, malaria was considered eliminated from the United States.

With the successful elimination of malaria in the United States, CDC would soon switch its focus from malaria to prevention, surveillance, and technical support for other diseases both at home and abroad.

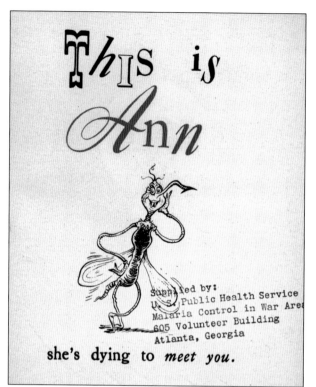

Before Horton heard his first Who, Dr. Seuss (Theodor Geisel) helped to inform United States troops of the dangers of malaria. As a captain in the Army during World War II, Geisel used his artistic talent to create training films and pamphlets for the troops. One of Geisel's early pieces was a booklet aimed at preventing malaria outbreaks among GIs by urging them to use bed netting and repellents. The booklet explained how to avoid "blood-thirsty Ann," created to represent *Anopheles quadrimaculatus*, the malaria mosquito.

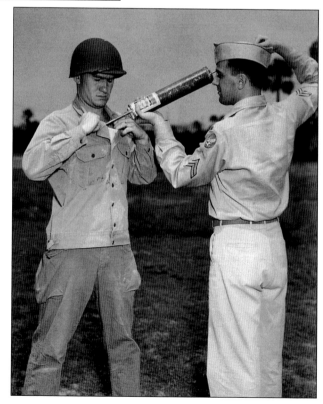

A US Army soldier demonstrates DDT-spraying equipment while applying the insecticide. The introduction of DDT in 1944 profoundly affected the landscape of malaria control. The World Health Organization claims that the use of DDT saved 25 million lives.

By the 1940s, communications and graphic styles had evolved into direct, no-nonsense messages—far from the dramatic illustrations used in the late 19th century to depict serious health issues (such as the *Harper's Weekly* drawing on page 16). The cover of this yearly progress report left no doubt about the subject matter: the relationship between malaria control and mosquitoes. This book contains numerous examples of successful posters produced by the US Public Health Service and CDC to communicate with the public about urgent health issues in a simple, easy-to-understand manner.

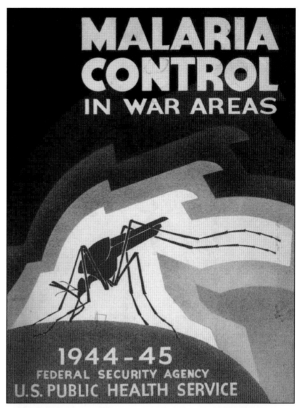

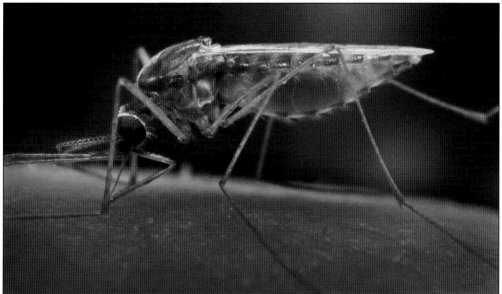

This is the *Anopheles quadrimaculatus* mosquito, which was the malaria mosquito prevalent in the Southeast and the primary target of Malaria Control in War Areas research and control. While there are approximately 3,500 species of mosquitoes, human malaria is transmitted only by females of the genus *Anopheles*. Of the approximately 430 *Anopheles* species, only 30 to 40 transmit malaria.

The CDC mobile laboratory (above) provided rapid field diagnosis under epidemic conditions. Below is a typical, not-so-glamorous 1943 Malaria Control in War Areas field office in a warehouse in Savannah, Georgia. Money and space were tight during the war years, so more attention was given to securing equipment and transportation for workers than providing them with office accommodations. During the height of its operations, MCWA was doing control work in approximately 2,000 locations in 19 states. Highly mechanized equipment included boat- and truck-mounted high-pressure sprayers and oil-water centrifugal pumps, which were maintained in buildings such as the one shown here. In 1943, the US Public Health Service employed over 4,300 people. Approximately 3,000 of these people were laborers in malaria control work supervised by physicians, engineers, and entomologists.

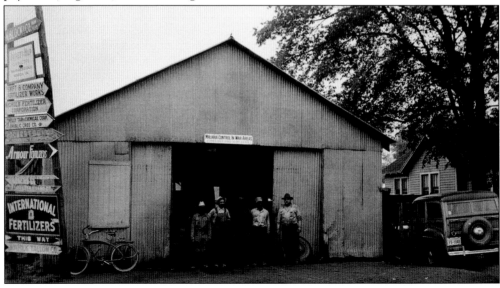

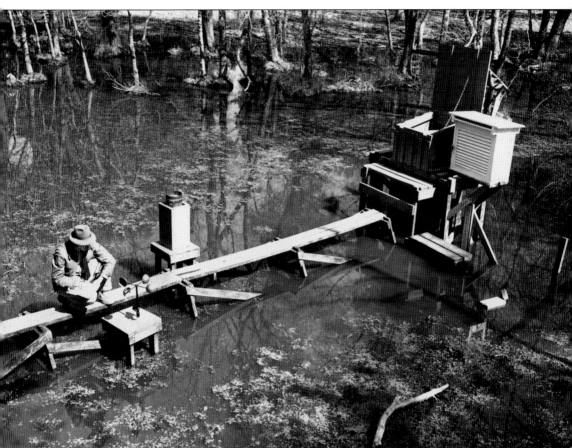

In 1929, Coca-Cola Company chairman Robert Woodruff and a business partner, Walter White, purchased 36,000 acres in southwest Georgia to use as a hunting reserve, creating the Ichauway Plantation. Woodruff learned that many of the tenant farmers in the area and their families suffered from malaria. He consulted with Coca-Cola's medical advisor, Dr. Glenville Giddings, who was also advising Georgia Power regarding its employees who had contracted malaria while clearing land and building dams. Woodruff and Giddings established a facility with a staff of researchers, doctors, nurses, and technicians to provide malaria control and research at Ichauway. The project soon began providing detailed information about how the mosquito population multiplied and infected humans with the disease. Eventually, Ichauway became home to the Emory University Field Station, which is pictured in 1945 with a field researcher collecting data on pond height, water temperature, and wind movement as part of the malaria study. This station provided numerable benefits for Malaria Control in War Areas in terms of transmission rates and the relationship of malaria organisms to the environment. (Emory University's Manuscript, Archives and Rare Book Library.)

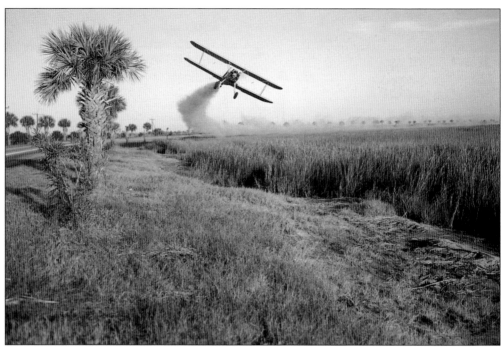

Airplanes became important tools for dispersing insecticides in the battle against insect-borne diseases. The above image shows a Stearman biplane spraying insecticide to help eliminate mosquito populations near Savannah, Georgia, while the below image shows a public health employee taking aim in a wooded lakeside area. Adult mosquitoes could be killed by small droplets of contact insecticide. Using these spraying techniques, larvicide could be applied to vast stretches of watery swamps. Aerial spraying—using newer and more eco-friendly insecticides—is still a very effective method of controlling mosquitoes. DDT, first developed during World War II, was very effective in combating vector-borne diseases such as malaria and typhus, but in June 1972, the Environmental Protection Agency banned its use in the United States due to the damage it can cause to the human body.

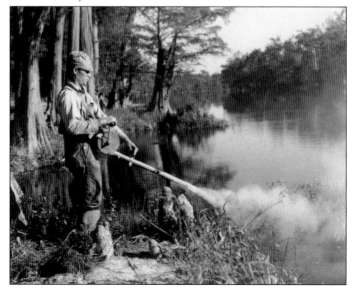

Malaria had been a major scourge throughout much of US history, particularly in the South. Since domestic mosquitoes are often found breeding in old discarded tires, a researcher in the 1940s is shown above collecting larvae of domestic species—including *Culex quinquefasciatus*, *Culex pipiens*, and *Aedes aegypti*—for use in the study of viruses transferred by insect vectors. Rural Southern families, like the group shown below sitting on an unscreened porch, were at risk of getting malaria from mosquito bites. Adding extensive screening to houses was a step that helped to bring malaria under control. (Below, National Library of Medicine.)

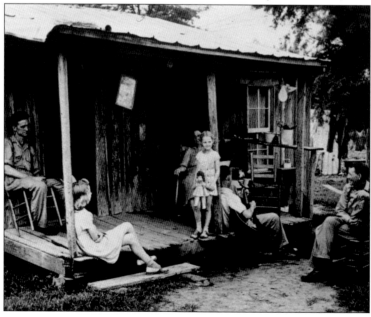

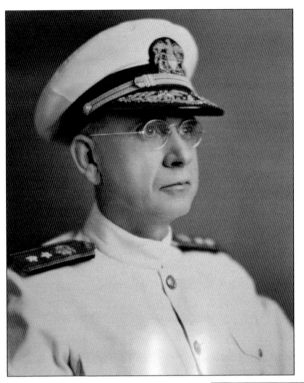

Dr. Joseph W. Mountin, founder of CDC, established the agency in 1946 along with Dr. Thomas Parran and US Public Health Service engineer Mark Hollis. Dr. Mountin's credentials included serving as Assistant Surgeon General of the United States and as chief of the Bureau of State Services of PHS. He is often referred to as the "father" of many of the public health programs still active today.

Dr. Thomas Parran, sixth Surgeon General of the United States, poses in front of a display board showing posters for some of the public health campaigns undertaken during his tenure. Malaria Control in War Areas (MCWA) was created under his watch, and Dr. Parran made the decision to locate CDC in Atlanta. As the former chief of the Public Health Service's Division of Venereal Diseases, his efforts helped sway public sentiment away from moral condemnation of venereal diseases and toward acceptance of them as medical conditions and threats to public health.

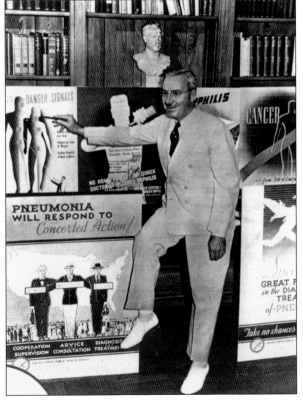

On July 1, 1946, the Communicable Disease Center officially opened as a field station in the Bureau of State Services of the US Public Health Service. CDC occupied the old offices of Malaria Control in War Areas, which were located on the sixth floor of the Volunteer Building in downtown Atlanta. CDC was created to assist state and territorial health departments in field training and to supply evaluation and consultation services in public health diagnostic laboratories as well as a program for the control of communicable diseases.

CDC established a satellite campus adjacent to property that had formerly been Camp Gordon, a World War I–era training camp in Chamblee, Georgia. Consisting of reconfigured barracks and portable buildings, this campus featured the majority of fledgling CDC laboratories, including this mycology unit built in 1947. Mycology deals with the study of fungi and their use to humans as a source for medicine (such as penicillin) as well as their dangers to humans through poisoning or infection.

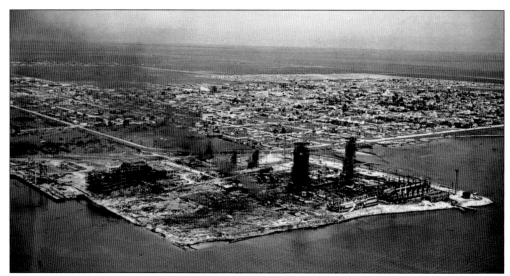

In early 1947, CDC was abruptly called upon to offer disaster aid in response to multiple chemical explosions in Texas City, Texas. The bustling Galveston Bay port city was home to numerous chemical plants and oil refineries. On April 16, a fire on the French freighter, *Grand Camp,* ignited ammonium nitrate and other explosive materials in the ship's hold, causing a massive blast that destroyed much of the city and claimed nearly 600 lives. A second freighter, the *High Flyer,* also loaded with ammonium nitrate, exploded the following day, further devastating the city. Within hours of the first explosion, CDC employees were at the site, tasked primarily with food safety and keeping flies and mosquitoes under control to protect against the outbreak of disease. The successful response to the Texas City crisis ultimately led to CDC being designated as the "official" response agency for future epidemics and disasters. By 1949, CDC had responded to 21 epidemics and disasters (primarily floods). (Both, Moore Memorial Public Library, Texas City, Texas.)

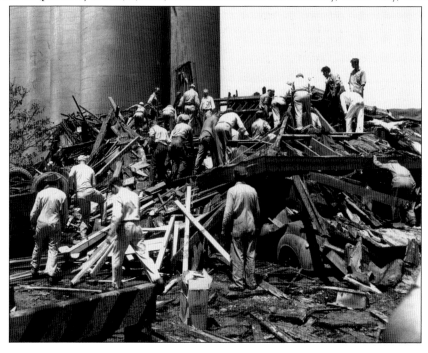

Three

THE 1950S
THE "WAR BABY" GROWS UP

By the 1950s, CDC's reputation was gaining momentum as its visionary leaders focused on expanding its role to include all communicable infectious diseases. Eminent scientists vied for jobs in CDC laboratories, while states and foreign countries sent a steady stream of public health staff to Atlanta for training.

Dr. Alexander Langmuir, who joined CDC in 1949 to head the epidemiology branch, was tasked with creating teams to investigate any kind of epidemic. In 1951, he founded the Epidemic Intelligence Service (EIS), a two-year program intended to assist states in investigating infectious disease outbreaks while providing on-the-job training in epidemiology. EIS alumni quickly became known as "shoe-leather epidemiologists" or "disease detectives," evoking an image of investigators walking door-to-door using surveillance methods to investigate disease outbreaks.

A watershed moment for CDC occurred during the national polio epidemic in the mid-1950s with what came to be known as the "Cutter incident." In 1955, CDC introduced a new polio vaccine (created by Dr. Jonas Salk), and an EIS surveillance team was immediately put into place in anticipation of any vaccine failures. Two weeks after the release of the vaccine, on April 26, 1955, William Workman, the director of the Laboratory of Biologics Control (the federal agency responsible for licensing biologic products in the United States), received a series of telephone calls about five children in California who had become paralyzed after receiving the polio vaccine. In each case, paralysis occurred in the arm that was inoculated, and in each case, the vaccine had been made by Cutter Laboratories.

Through EIS surveillance efforts, the problem was quickly traced to improper production methods at Cutter Laboratories in California. As a result, the laboratory introduced new requirements for safety testing and improved manufacturing methods. The problem was corrected, and the polio immunization program resumed.

Two years later, in 1957, EIS used surveillance once again to track the course of a massive Asian flu epidemic. CDC developed national guidelines for influenza vaccine from data gathered in 1957 and subsequent years.

In addition to responding to infectious disease issues, EIS officers also utilized their surveillance methods to explore venereal disease, family planning, birth defects, cancer cluster investigations, and environmental health problems throughout the world. This was all done with the notion of using data to control and prevent future disease and reduce mortality rates.

In 1957, the Venereal Disease Division of the US Public Health Service was transferred to CDC by Surgeon General Leroy E. Burney, doubling CDC's budget and personnel. The transfer provided representation in regional offices and added two important innovations to CDC's activities: a grant program and a new kind of employee, the public health advisor (PHA). PHAs got to know state and local health departments and would become important to the success of CDC.

The "war baby"—as CDC had been referred to in an early press release—was growing up.

The first Epidemic Intelligence Service class began in 1951. After completing their two-year program, modeled after the traditional medical residency program, the officers presented EIS director Dr. Alexander Langmuir (pictured) with a gift: two framed leather soles, signed by the class, symbolizing the "shoe leather" epidemiology practiced by the EIS. This began a tradition of EIS class gifts that continues today. The EIS class of 1951 consisted of 22 physicians and one sanitary engineer.

This c. 1959 photograph shows Epidemic Intelligence Service officials in a meeting at the CDC. Pictured here are, from left to right, Dr. Philip Brachman, EIS founder Dr. Alexander Langmuir, Dr. Donald A. Henderson, and Dr. Robert Courter. Each of these individuals played a significant role in the creation and development of the EIS program. In the late 1940s and early 1950s, epidemiologists trained to do fieldwork were in short supply, and Dr. Langmuir quickly saw the need to establish a training program.

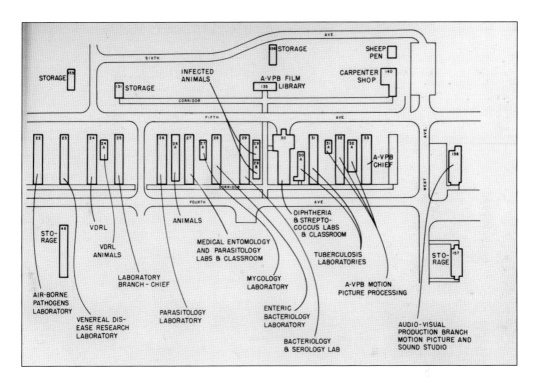

As CDC began to grow and take on more responsibilities, it became evident more space was needed, so the Chamblee campus was reconfigured with an emphasis on CDC lab space, as shown in the 1952 drawing above. The 1957 image below shows a group of laboratorians attending a class on venereal disease on the Chamblee campus. Laboratory protocols are much different today. Gloved hands and proper laboratory coats are now considered necessary to maintain a clean, sterile environment free of contaminants.

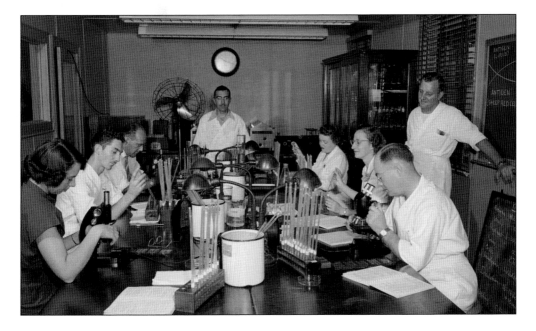

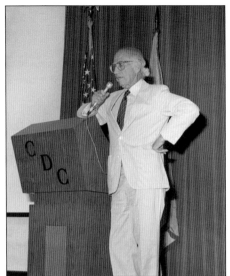

This photograph shows Dr. Jonas Salk, who introduced the first polio vaccine in 1955, fielding questions during a presentation at CDC in 1988. The successful polio vaccine developed by Dr. Salk and his team of scientists was announced on April 12, 1955. "Safe, effective, and potent" were the words used to describe the new vaccine. At its height, polio paralyzed 13,000 to 20,000 people each year in the United States.

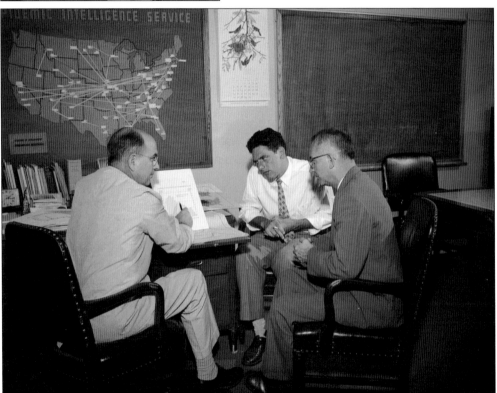

Officers from the Epidemic Intelligence Service Polio Surveillance Unit are pictured discussing investigative strategies. Pictured here are, from left to right, EIS creator Dr. Alex Langmuir, Dr. Jack Karush (EIS, class of 1954), and CDC statistician Robert Serfling. The first known outbreak of polio in the United States was in 1894, but the epidemics in the 1950s held American families in a grip of terror. In 1952, a record 57,628 cases of polio were reported in the United States. Parents attempted to protect children by keeping them out of public places such as pools, parks, and theaters.

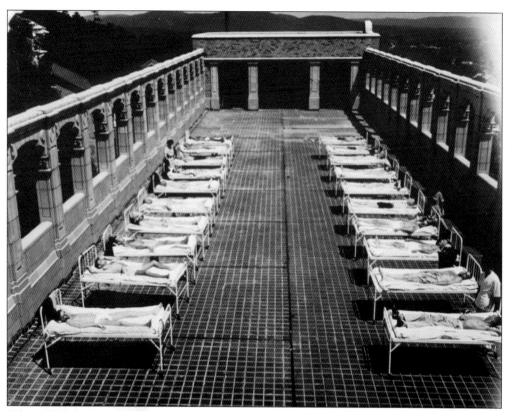

Poliomyelitis (polio) is a crippling and potentially deadly infectious disease caused by the poliovirus. The virus spreads from person to person and can invade an infected person's brain and spinal cord, causing paralysis. In about 1 in 200 cases, the virus destroys the nerve cells that activate muscles, causing irreversible paralysis, usually in the legs. During the polio epidemic of the 1950s, hospital rooftop decks were sometimes used to give victims a breath of fresh air (above). Polio can paralyze breathing muscles, too, sometimes causing death. The negative pressure ventilator, also known as an iron lung (below), was initially used for victims of coal gas poisoning and became a treatment to help polio victims breathe when normal muscle control had been lost. (Above, National Library of Medicine.)

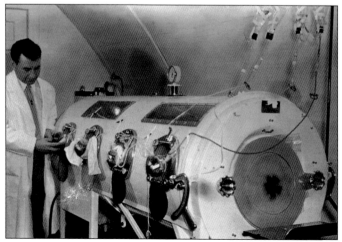

Around the same time that Jonas Salk began his work on a killed-virus vaccine, Dr. Albert Sabin (left) began work on an attenuated live-virus vaccine. Sabin strongly disagreed with Salk's approach of using injected "killed" virus. He believed that long-term immunity could only be achieved with a live virus. Sabin also felt that an oral vaccine would be superior to an injection, as it would be easier to administer. Many baby boomers may recall taking the oral vaccine in the early 1960s via sugar cubes laced with Sabin's vaccine (below). By the end of the 1960s, the Sabin vaccine became the primary vaccine for worldwide polio prevention. The global treatment would have been inconceivable without both the "killed" (Salk) and "live" (Sabin) vaccines. Neither Salk nor Sabin patented their vaccines; they donated the rights as gifts to humanity. (Left, National Library of Medicine.)

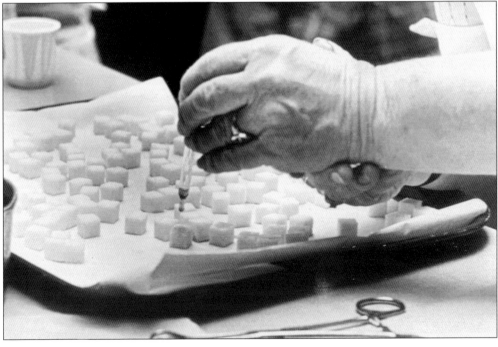

During the 1950s, protecting the public from polio became a nationwide project. CDC made every effort to ensure the vaccine would be widely available to children and adults. Images like this were used in promotional campaigns to encourage individuals to receive polio vaccinations. Thanks to CDC's successful nationwide immunization programs, polio is now considered a preventable viral infection; today, it is rarely seen in the United States but still occurs in some parts of the world.

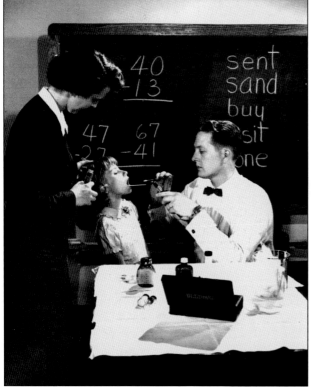

In this image, CDC's second chief Epidemic Intelligence Service officer, Dr. Ira Myers, performs a throat swab on a young student. Laboratory tests used in the diagnosis of *poliomyelitis* often included viral cultures of throat swabs. To eradicate polio in the United States, state and local health departments partnered with CDC to vaccinate millions of people. CDC provided support through surveillance of outbreaks, distribution of vaccines, and coordination of vaccination campaigns. By 1956, the United States reported half as many polio cases as in the previous year.

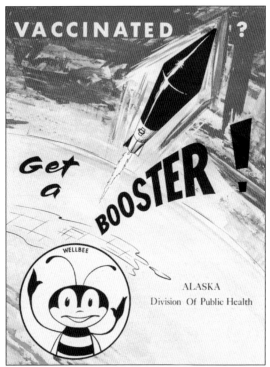

VACCINATED ?

Get a BOOSTER!

WELLBEE

ALASKA
Division Of Public Health

When CDC was still the Communicable Disease Center, Public Information Officer George M. Stenhouse wanted to develop a public health symbol for use by public health agencies across the country. In response, CDC staff artist Harold M. Walker, who previously worked as an animator on cartoons such as *Felix the Cat*, designed Wellbee, a cartoon character that exemplified "well-being." CDC used Wellbee in comprehensive marketing campaigns and made appearances at public health events.

Below, Wellbee poses at Fenway Park with Boston Red Sox players Bill Monbouquette, pitcher (left); Dick "The Monster" Radatz, relief pitcher (center); and Eddie Bressoud, shortstop. The Wellbee character was later incorporated into other health promotion campaigns including those for diphtheria and tetanus immunizations, hand washing, physical fitness, and injury prevention.

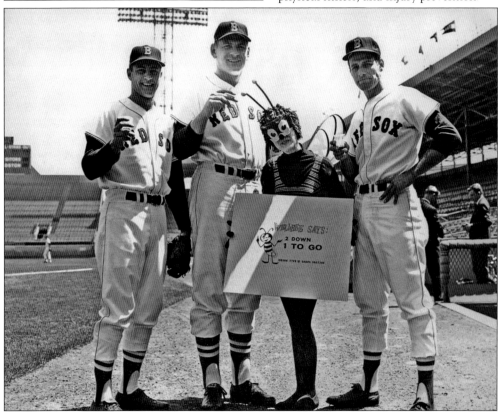

In 1957, CDC's Laboratory Branch developed a more accurate and faster way of diagnosing specimens—the fluorescent antibody technique (FA), in which pathogens could be stained different colors, making diagnosis much easier. The technique was simple, reliable, and economical. Before FA, diagnosing cultures using monkeys could cost as much as $200; using the FA technique cut the cost to about $10. The technique, initially used to shorten the time needed to identify organisms that might be used in biological warfare during the Korean and Cold War eras, soon mushroomed into numerous applications for diseases such as yellow fever, pertussis, malaria, syphilis, gonorrhea, and rabies. Below, a CDC scientist views a specimen using direct fluorescent antibody staining and an epi-illumination microscope.

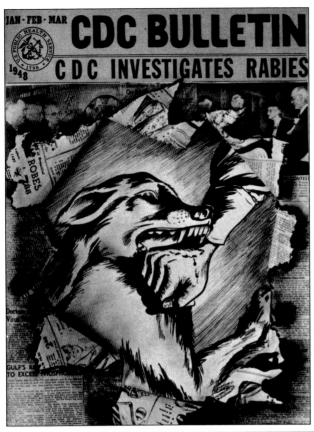

CDC began investigating rabies in the late 1940s, and rabies was first diagnosed in bats in Florida in 1953. At the end of 1965, infected bats had been discovered in all states except Rhode Island, Alaska, and Hawaii. Dr. Denny Constantine, a CDC Epidemic Intelligence Service officer and veterinarian, conducted a five-year study on rabies and concluded that "under special conditions in a bat cave," rabies could be spread through the air. Dr. Constantine went on to establish and become the chief of the CDC Southwest Rabies Investigation Station in Las Cruces, New Mexico (below). By 1959, CDC had developed fluorescent antibody tests for rabies.

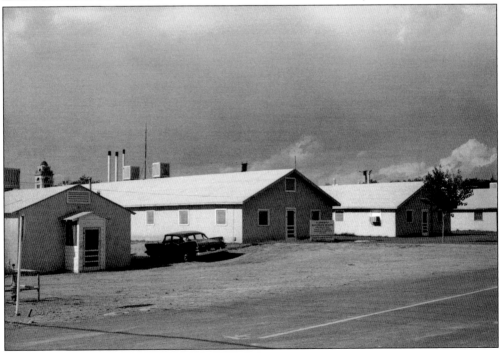

This 1958 photograph shows a worker wearing protective clothing in Lompoc, California, while handling bags of diatomaceous earth, which has various uses, including as a stabilizing component in dynamite. Images like this were used to document aspects of various industrial activities to better understand workplace environments and their associated hazards. After gaining a better understanding of workplace hazards, CDC was able to develop protocols during the 1950s to create safer workplaces through appropriate regulations.

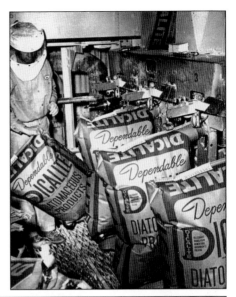

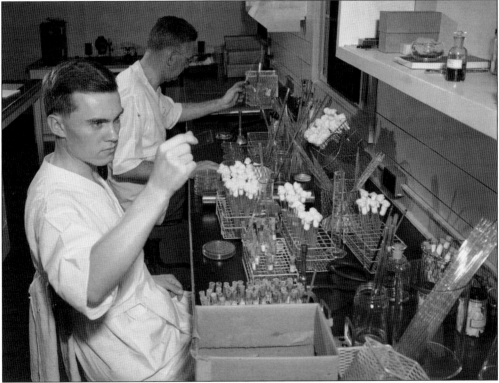

US Public Health Service and CDC scientists Dr. P.R. Edwards (background) and George Herman are pictured in an Enteric Bacteriology Unit laboratory performing a study focused on bacterial organisms, which are known to cause gastrointestinal diseases like diarrhea and dysentery. By the late 1950s, CDC scientists had experienced great success in the study of enteric pathogens in the digestive tract and other body organs that can produce toxins and carcinogens implicated in conditions such as multisystem organ failure, sepsis, colon cancer, inflammatory bowel disease, salmonella, and hepatitis.

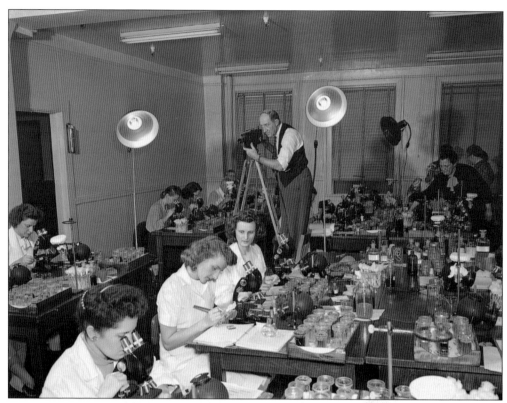

By the 1950s, the CDC audiovisual department produced more film and filmstrips than the rest of the US Public Health Service combined. CDC primarily used these to train domestic and foreign public health workers. The films, along with extensive training programs, enabled states to train their own health workers at facilities scattered around the nation. In addition, both domestic and foreign scientists flocked to CDC's Atlanta headquarters to hone their public health skills. The audiovisual unit, below, eventually located on the Clifton Road campus, contained two large stages that were each three stories high, numerous darkrooms, and a quality sound department.

When CDC formed in 1946, the agency's contributions to international health focused on malaria control and training local health care workers. CDC's growing reputation for fighting diseases such as cholera, smallpox, and malaria reached full global status when CDC sent its first epidemiologists abroad to assist with infectious emergencies such as smallpox in Pakistan. This 1950 photograph shows a team spraying for malaria in Vietnam.

The Asian flu pandemic emerged in Hong Kong in 1957 with millions of cases causing thousands of deaths. CDC's epidemiology and laboratory branches worked in tandem to quickly set up a surveillance system enabling national control activities for the United States. As the epidemic swept across the United States, CDC epidemiologists precisely plotted its course as laboratorians rapidly created a new vaccine. By the early months of 1958, over 40 million doses of the vaccine had been distributed. CDC's responses to the polio and influenza crises of the 1950s greatly enhanced the reputation of the fledgling institution.

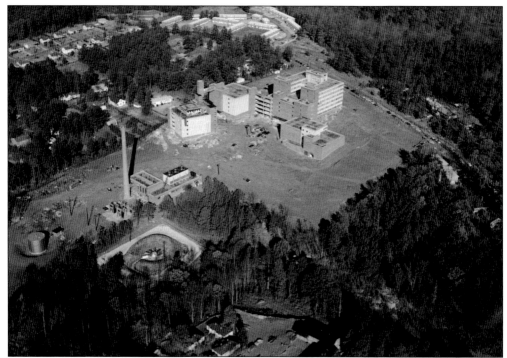

In 1947, Emory University, at the behest of Coca-Cola Company chairman and longtime Emory board member Robert W. Woodruff, sold 15 acres of land to the US Public Health Service for a token payment of $10. In 1959, through the skillfulness of Woodruff in conversation with Pres. Dwight D. Eisenhower to secure funding, work began on constructing the campus buildings. The buildings were dedicated on September 8, 1960. The above photograph offers a view of the CDC building under construction in 1959, while the below photograph shows the finished campus shortly after its dedication.

Four

THE 1960S
NEW CHALLENGES SHAPE CDC's FUTURE

The 1960s, a period of social change in America, began with great promise. A new, young president was leading the country into the New Frontier, and 70 million children from the postwar baby boom were becoming teenagers and young adults. Young people wanted change, and those changes would come to affect every aspect of life in America. The cultural fabric of the country exploded into a cultural revolution replete with a national consciousness that included improving the health of the nation. Even after the death of Pres. John F. Kennedy, his successor Lyndon Johnson's dream of a "Great Society" was compatible with CDC goals.

With exciting scientific advances and a legacy of helping win the battle against polio in the 1950s, CDC rapidly broadened its responsibilities on a grand scale. The agency's reputation led to its involvement in a number of acquisitions and initiatives: the tuberculosis program, evolving immunization practices, foreign quarantine measures, a national nutrition program, family planning, and investigations into birth defects and the dangers of smoking. Research became safer when, in 1969, CDC technicians created "biocontainment labs"—airtight laboratories outfitted with special safety measures used to protect scientists while they worked with deadly and infectious pathogens. While CDC achieved much success in these burgeoning health care areas, one of its greatest victories, the worldwide eradication of smallpox, permanently transformed CDC into a major presence on the global health care stage.

In Africa, in the early 1960s, a greater health threat than smallpox was measles, which ravaged the continent and killed approximately 10 percent of African children before the age of five. Working with partner health care agencies, CDC assisted with a massive measles immunization campaign that began in 1962. Epidemic Intelligence Service official Dr. D.A. Henderson proposed combining a smallpox eradication campaign with the measles immunization program, noting that it would be "humanely urgent and economically feasible." In 1966, CDC initiated a Smallpox Eradication/Measles Control Program in 18 West African countries. The agency refined mass vaccination techniques and used a "surveillance and containment" strategy to speed the work. Under the auspices of a World Health Organization (WHO) team, which included hundreds of CDC staff, the eradication of smallpox was on the horizon by the end of the decade.

CDC victories during the 1960s put it on track to become the nation's premier health promotion, prevention, and preparedness agency and a global leader in public health in the coming decades.

Images were an extremely powerful tool used in the fight against the spread of venereal disease and other sexually transmitted diseases in the 1960s. The focus on venereal diseases was especially accelerated during the "free love" movement, when people were stretching accepted values about sexuality. This poster was created for the Society for Individual Rights (SIR) in San Francisco. SIR, which formed in San Francisco in 1964, worked in cooperation with the Public Health Department of California to educate the public about venereal disease.

This photograph shows a physician and nurse examining a tuberculosis-positive chest x-ray. After a positive skin test, a patient is required to have a chest x-ray to see if the subject has the active form of the disease. When the Tuberculosis Division moved to CDC in 1960, the fluorescent antibody technique, which had become an invaluable tool for CDC scientists, was utilized to type the tuberculosis organism, expediting treatment of the disease.

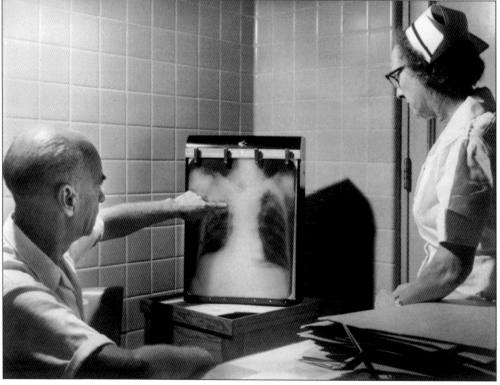

In 1961, the *Morbidity and Mortality Weekly Report* (MMWR) moved to CDC from the National Office of Vital Statistics. Often called "the voice of the CDC," *MMWR* is the agency's primary vehicle for scientific publication of timely, reliable, authoritative, accurate, objective, and useful public health information and recommendations. For over 50 years, *MMWR* has never missed its weekly Thursday publication deadline.

The first *Surgeon General's Report on Smoking and Health*, issued on January 11, 1964, outlined the dangers of smoking and diseases related to the habit. One year later, Congress passed the Federal Cigarette Labeling and Advertising Act, which banned cigarette advertising in broadcast media, required health warnings on cigarette packages, and provided the impetus for antismoking campaigns still being conducted today by public health agencies.

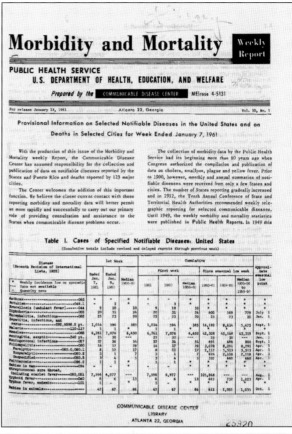

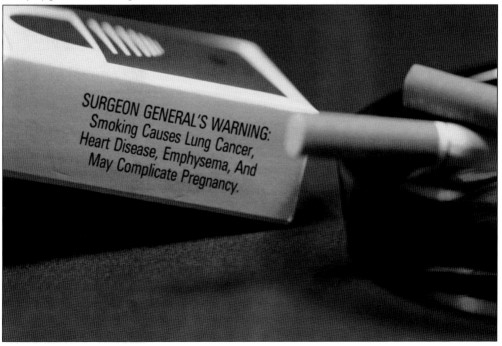

This 1966 photograph shows a laboratory technician using a manual method to conduct a cholesterol determination. In the 1960s, CDC greatly expanded its efforts regarding preventive health services. After determining that high cholesterol levels may be linked to heart attack and stroke, CDC developed accurate cholesterol measurement procedures that led to the creation of the Cholesterol Standardization Program; this program's guidelines, which have been updated over the years, are still in use today.

The popularity of global transportation in the "jet age" of the 1960s added new problems for CDC scientists, because tropical diseases such as malaria and dengue fever could accompany travelers when they returned to the United States; these problems continue today. CDC had been conducting training (pictured) on tropical diseases since the 1940s, but it continued to study tropical illnesses into the 1960s with a goal of achieving global eradication for many of the diseases.

This 1965 image shows a CDC scientist seated at a new transmission electron microscope (TEM). A TEM uses a beam of electrons passed through an extremely thin specimen and onto an imaging surface, which makes the specimen become visible. The TEM makes it possible to reveal details tens of thousands of times smaller than those that could be observed with even the highest-quality light microscope.

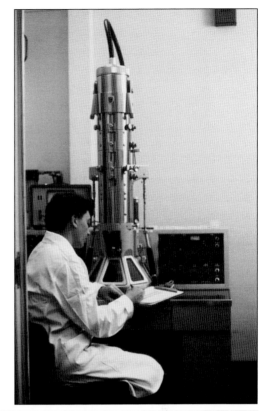

The 1960s was a decade of growth for CDC, as a number of national agencies were transferred to its ranks by the federal government. One of the oldest and most prestigious units of the US Public Health Service, the Foreign Quarantine Service, joined CDC in 1967. As a result, the service developed better ways of doing the work of quarantine, primarily through overseas surveillance. This PHS ship is shown anchored in New York Harbor.

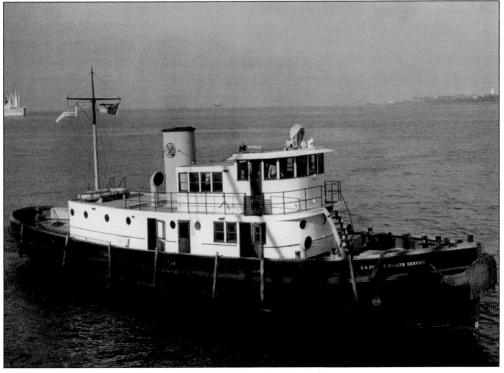

The Salk polio vaccine of the 1950s gave way to the Sabin vaccine in the 1960s, and CDC encouraged the general population to continue receiving vaccinations. This aerial photograph shows a crowd surrounding a city auditorium in San Antonio, Texas, to await polio immunization in 1962.

This 1964 photograph shows First Lady Claudia "Lady Bird" Johnson wielding a shovel at a ground-breaking ceremony for new additions to CDC's headquarters. At left is then-director Dr. James L. Goddard (in his crisp PHS uniform), and at right is Boisfeuillet Jones, vice president of Emory University, who was on leave from the college to serve as an advisor in the White House.

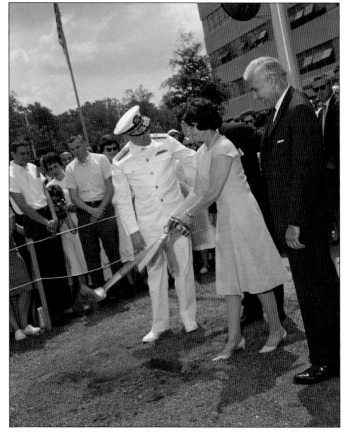

Before the measles vaccine became available in 1963, the disease caused approximately three to four million infections and an average of 450 deaths each year in the United States. More than half the population had measles by the time they were six years old. This image shows a doctor giving a measles vaccination to a young boy at Fernbank School in Atlanta. Though measles is now highly controlled in the United States, the disease is still common in the developing world.

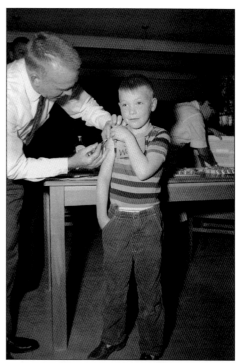

Dr. Harry Meyer Jr. (left) and Dr. Paul Parkman, developers of the Meyer-Parkman vaccine used to defeat rubella (German measles), are shown inspecting a culture of the virus used in preparing the vaccine. The pair introduced the first rubella vaccine in 1966. Dr. Meyer worked with former CDC director Dr. David Sencer on a number of health initiatives, including measles immunization and swine flu. In October 2004, CDC convened an independent panel that found rubella was no longer endemic in the United States. (National Library of Medicine.)

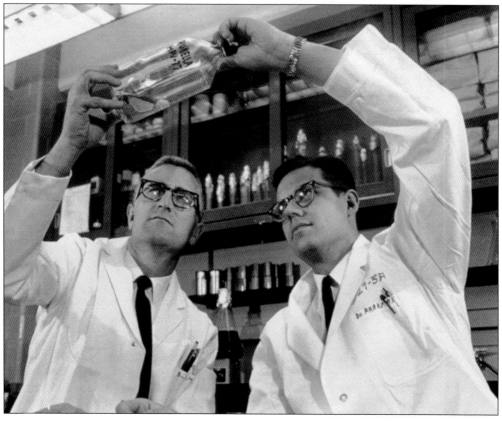

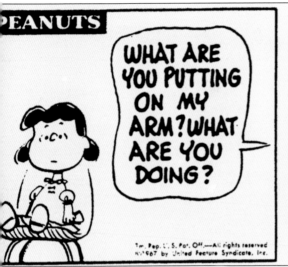
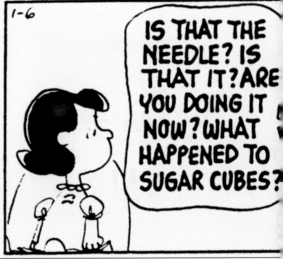

The first live attenuated vaccine, the Edmonston B strain, was licensed for use in the United States in 1963. Before the measles vaccine, nearly all children got measles by the time they were 15 years old and about 500 people died, 48,000 were hospitalized, 7,000 had seizures, and about 1,000 suffered permanent brain damage or deafness each year as a result of measles. Once a vaccine was developed, all stops were pulled to encourage mass vaccinations. Cartoonist Charles Shultz, creator of the *Peanuts* comic strip, offered assistance by featuring a measles vaccination theme in four consecutive comic strips in early 1967. He cleverly refers to the sugar-cube method—which

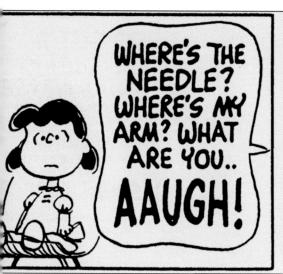
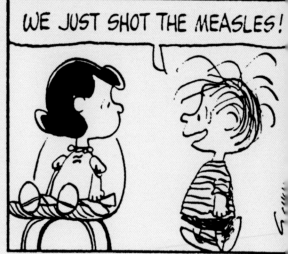

had been very popular with youngsters—used for polio vaccinations, but unfortunately, it was not feasible for the measles vaccination. Since the vaccine was introduced, there has not been a major measles epidemic in the United States. At its peak, *Peanuts* ran in over 2,600 newspapers, with readership of 355 million in 75 countries, and was translated into 21 languages, making it an excellent vehicle for communicating the value of measles vaccination worldwide. (Both, PEANUTS © 1967 Peanuts Worldwide LLC. Dist. By UNIVERSAL UCLICK. Reprinted with permission. All rights reserved.)

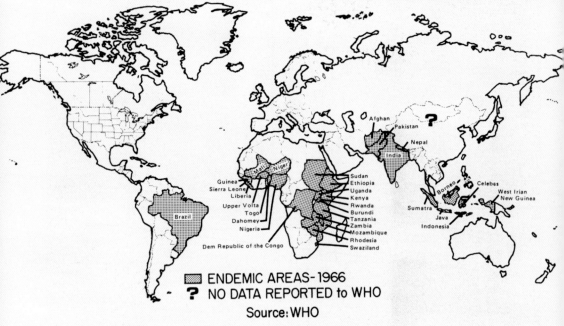

WORLD-WIDE SMALLPOX ENDEMIC AREAS, 1966

ENDEMIC AREAS-1966
? NO DATA REPORTED to WHO
Source: WHO

One of the major events leading to CDC globalization was its role in the Smallpox Eradication/ Measles Control Program in 21 countries of West and Central Africa from 1966 to 1977. Although the last case of smallpox in the United States was reported in 1949, this map shows that at the start of the campaign in 1966, the disease had been reported in 44 countries and was endemic in at least 33 of them. The disease was present across southern Asia (from Afghanistan to Malaysia and Indonesia), throughout most of Africa south of the Sahara, in the large South American countries of Brazil and Argentina, and in scattered locations in Europe and the Middle East.

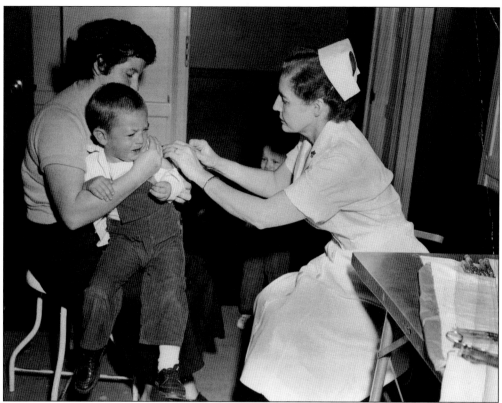

Above, a small child is shown receiving a smallpox vaccination in the 1960s at his local health department. The smallpox vaccine helps the body develop immunity to smallpox and is made from a virus called vaccinia, a pox-type virus related to smallpox. The smallpox vaccine contains the live vaccinia virus, not dead strains of virus like those used in many other vaccines. Below, a young boy from Cameroon receives his vaccinations during the Global Smallpox Eradication Program. Public health technicians are administering the requisite vaccines using a Ped-O-Jet jet injector applied to both of the boy's upper arms. A tremendous invention and inoculation aid, the Ped-O-Jet was invented by the US Army and adapted for CDC field use. It uses intense pneumatic pressure to painlessly shoot the vaccine into the patient's skin in a fraction of a second.

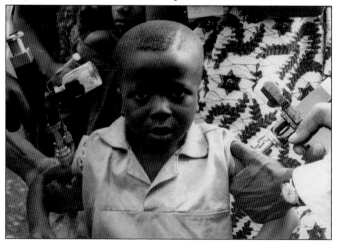

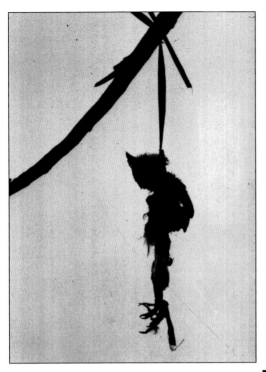

This photograph, taken in the Ivory Coast in West Africa, shows the carcass of a bird hanging from a pole—a macabre warning to travelers of the presence of smallpox. To prepare for their fieldwork in the smallpox eradication program, CDC epidemiologists and operations officers were trained in smallpox epidemiology, clinical aspects, and vaccine properties. They also received information on local customs, French language instruction, and lessons in motor vehicle repair. (WHO/National Library of Medicine.)

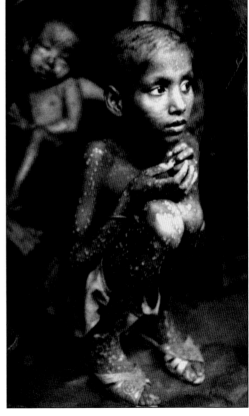

This image of a small child stricken with smallpox was taken during the global smallpox eradication campaign of the late 1960s and early 1970s. Smallpox is a serious, contagious, and sometimes fatal infectious disease. There is no specific treatment for smallpox, and the only prevention is vaccination. The name "smallpox" is derived from the Latin word for "spotted" and refers to the raised bumps that appear on the face and body of an infected person.

Shapona, the West African god of smallpox, is worshipped among the Yoruban people in Nigeria. The wooden figure is adorned with layers of meaningful objects such as a monkey skull, cowrie shells, and nails. Yoruba refers to both an African people and the belief system practiced by the people. In Yoruba, one prays to deities such as Shapona out of respect in the hope of alleviating the devastation wrought by diseases such as smallpox.

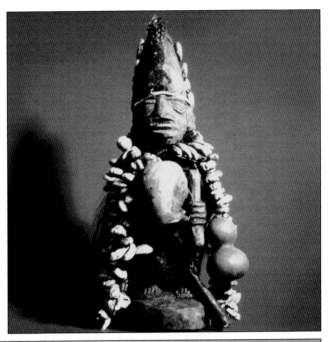

Containment of Smallpox Outbreak

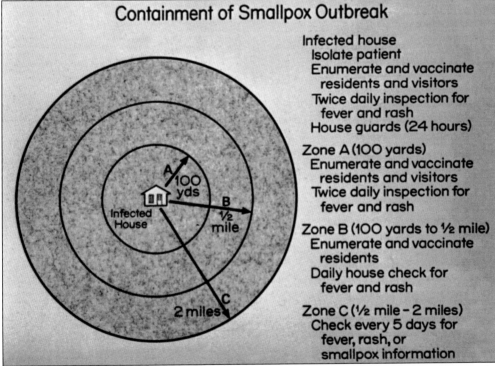

Infected house
Isolate patient
Enumerate and vaccinate
 residents and visitors
Twice daily inspection for
 fever and rash
House guards (24 hours)

Zone A (100 yards)
Enumerate and vaccinate
 residents and visitors
Twice daily inspection for
 fever and rash

Zone B (100 yards to ½ mile)
Enumerate and vaccinate
 residents
Daily house check for
 fever and rash

Zone C (½ mile – 2 miles)
Check every 5 days for
 fever, rash, or
 smallpox information

CDC's Smallpox Eradication Program teams utilized circular mapping techniques during the eradication campaign. Circular maps were integral to achieving a successful outcome, because they enabled public health practitioners to track smallpox cases that had been discovered and inhabitants who had been in contact with such cases. Health workers had to follow smallpox patients, as well as anyone associated with each patient, to a successful outcome.

A technician in a Bangladesh laboratory is shown creating smallpox vaccine. The vaccine consisted of calf lymph containing vaccinia virus prepared from live calves. The animals were infected by scarification, and the skin containing viral lesions was physically removed by scraping. Vaccine prepared by this traditional manufacturing technique of harvesting the virus from the skin of cows (and sheep) was used in most regions of the world during the Smallpox Eradication Program.

Prince Taufa'ahau Tupou IV of Tonga (who was soon to become King of Tonga) is shown receiving his smallpox vaccination from the CDC's Dr. Ron Roberto, who is using a Ped-O-Jet. In the summer of 1964, CDC tested the jet gun and vaccine in Tonga, a Polynesian archipelago of 150 islands with 65,000 subjects. No one in Tonga had ever been vaccinated, so CDC distributed photographs and films of the king being vaccinated to encourage the Tongalese to be step forward and get vaccinated, too.

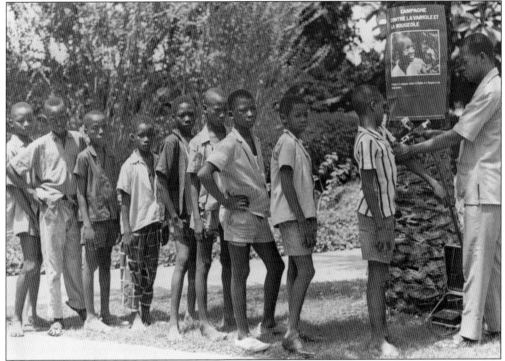

This photograph shows a group of young boys in West Africa being vaccinated by health practitioners using Ped-O-Jet guns while standing in front of a poster announcing smallpox eradication and measles control programs. The expertise gained in Africa served as a major resource when taking the eradication program to two countries that were thought to pose the greatest obstacle to global smallpox eradication: India and Bangladesh.

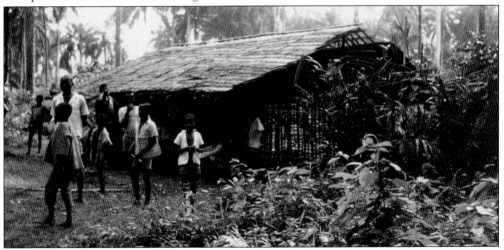

Individuals are shown outside of a typical eastern Nigerian house during the Nigerian-Biafran Civil War in the late 1960s. During the civil war, CDC participated in refugee support for two years by providing disease control and nutrition assistance. The devastating war caused a disastrous famine. The Nigerian government asked CDC to assist in determining the extent of the famine, resulting in epidemiologists immersing themselves in surveillance and the design of programs to combat malnutrition.

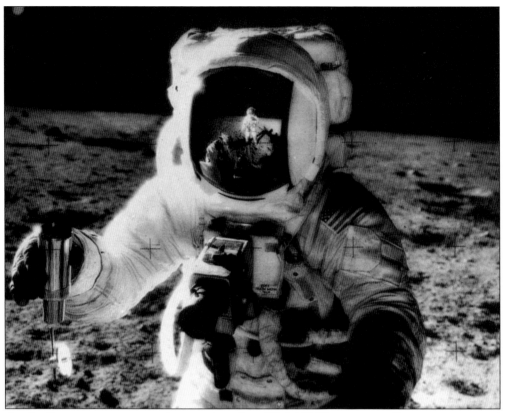

An Apollo astronaut poses on the moon's surface. With CDC's ever-expanding scope, it seemed a given that CDC would become involved in one of the biggest challenges of the decade: the exploration of space. CDC provided quarantine equipment and procedures for the United States space program, including the Apollo moon landings, and was asked to work with the National Aeronautics and Space Administration (NASA) to help prevent "space germs" from coming home with astronauts or germs from earth being sent into space. (National Library of Medicine.)

This 1966 aerial photograph shows CDC's headquarters. Throughout the 1960s, CDC grew immensely. It had become a national resource in communicable disease control serving state and local health departments through technical assistance, loan of personnel, and grants in aid. But it was the successful smallpox eradication and the malaria, measles and polio global health programs that took the agency beyond domestic responsibilities and thrust it onto the world stage.

Five

THE 1970s
CDC GROWS, CREATES NEW PREVENTION STRATEGIES

To reflect its widening range of responsibilities, the Communicable Disease Center name was changed by the federal government in 1970 to Center for Disease Control. Building upon the social justice movements of the 1960s, CDC expanded its efforts to address public health issues ranging from chronic disease prevention to environmental health to workers' health in the United States and around the world. At the top of the list was the continuation of the smallpox eradication program launched in 1966. Working with other global health organizations, CDC contributions helped defeat the ancient foe by 1977.

With its growing reputation and proven expertise, decisions were now being made by the federal government to place a number of "stand-alone" federal health agencies under the CDC umbrella. These included agencies dealing with family planning, diabetes, health-related consequences of lifestyle, and occupational/community environments. The 1973 dissolution of the Health Services and Mental Health Administration moved CDC up a notch in the Department of Health, Education and Welfare to become a full-fledged agency on par with the National Institute of Health.

By the 1970s, CDC's Office on Smoking and Health (OSH)—originally established in 1965 as the National Clearinghouse for Smoking and Health—became the nation's leading federal agency for comprehensive tobacco prevention and control. OSH was tasked with convincing a nation of smokers to "just say no" to tobacco; it did this by developing, conducting, and supporting strategic efforts to protect the public's health by reducing tobacco use and exposure to secondhand smoke. To address the worldwide epidemic of disease and death caused by tobacco, OSH began working with international partners to expand the global science base through surveillance and research; building capacity for data collection, analysis, and reporting; and assisting with linking surveillance data to tobacco control efforts.

The transfer of the National Institute for Occupation Safety and Health (NIOSH) to CDC in 1973 led to rapid, much-needed changes in the nation's workplace environments. Two health scares, one domestic (Legionnaires' disease) and the other in Africa (Ebola), provided new challenges for CDC epidemiologists and scientists. Proven CDC tactics quickly contained both deadly outbreaks.

Although one success rapidly followed another at CDC, it was inevitable that criticism would eventually find its way to the agency's doorstep. The Tuskegee study of the long-term effects of untreated syphilis on African American men, a program started by the US Public Health Service in 1932, was transferred to the CDC in 1957. Once the ethical issues of the project were made public by a whistleblower, CDC brought the study to an end in 1972. Another stumbling block occurred when a potential outbreak of swine flu late in the decade called for the immediate need to vaccinate millions of Americans. The development of Guillain-Barré syndrome in a few of those who were vaccinated created another controversial situation, although it was never verified that onset of the syndrome had been caused by the vaccine.

As the 1970s drew to a close, little did the CDC team realize how many of these new advancements would soon be used to address an emerging scourge waiting in the wings—AIDS.

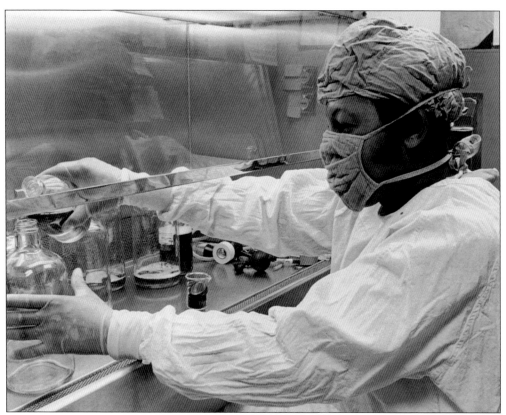

The Occupational Safety and Health Act of 1970 established the National Institute for Occupational Safety and Health to develop better workplace safety and public health standards through its partnership with the Occupational Safety and Health Administration (OSHA). In 1973, NIOSH was transferred to CDC along with the Bureau of Community and Environmental Management—the beginning of the CDC Environmental Health division. In the 1970s image above, a NIOSH chemist demonstrates techniques to ensure the safe handling of chemicals when testing field samples. Below, a man takes dust samples in 1976; these samples revealed high levels of lead contamination in the homes of children whose mothers worked in a battery factory in North Carolina. These and similar occupational and general health violations were primary targets of NIOSH, along with issues such as water fluoridation and workplace noise.

With its growing commitment to chronic health issues in the 1970s, the CDC added a diabetes division in 1977. The name was later changed to Division of Diabetes Translation, meaning that it translates science into daily practice such as monitoring glucose levels (pictured). In its "translation" research, the division took newly discovered information and incorporated it into clinical and public health practices, helping the public to understand the impact of the disease.

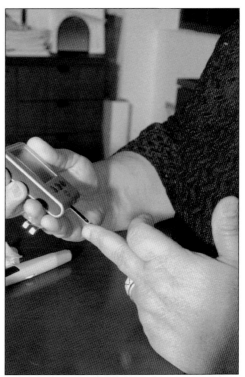

Three former directors of the Global Smallpox Eradication Program—Dr. J. Donald Millar (left), Dr. William H. Foege (center), and Dr. J. Michael Lane—read the good news that smallpox had been eradicated on a global scale. The worldwide eradication of this dreaded virus was due to the smallpox eradication campaign of the late 1960s and early 1970s. The vaccination program that was instituted across the globe led to the 1978 declaration by a global commission that smallpox had been eradicated, which was officially accepted by the 33rd World Health Assembly in 1980.

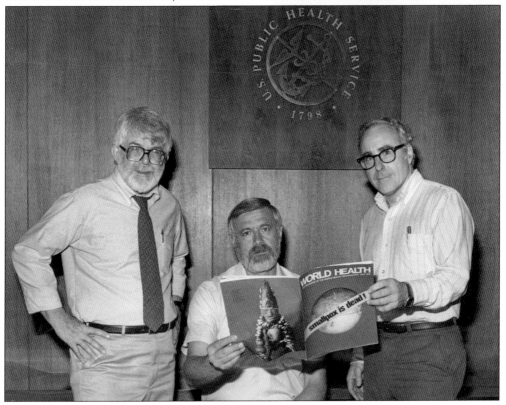

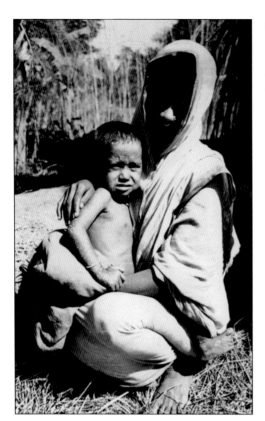

This 1975 image shows a mother holding her two-year-old daughter, Rahima Banu, who had the last known case of naturally occurring *variola major* smallpox in the world. The case occurred in the Bangladesh district of Barisal, in a village named Kuralia, on Bhola Island.

In 1977, Ali Maow Maalin, a Somali hospital cook and health worker from Merca, was the last person known to be infected with endemic or naturally occurring *variola minor* smallpox in the world. Maalin fully recovered and was subsequently involved in the successful poliomyelitis eradication campaign in Somalia. He died in 2013 of malaria while working in the polio eradication program.

The Bellevue-Stratford Hotel in Philadelphia was ground zero for the Legionnaires' disease outbreak that occurred in 1976. The mysterious outbreak was caused by an unknown bacterium later identified at CDC and named *Legionella pneumophila*, acknowledging the American Legion members who contracted the disease while attending a convention.

Microbiologist Joseph E. McDade, PhD (left), and Charles C. Shepard, MD, director of CDC's Laboratory Division, are shown in 1977 in the CDC Leprosy and Rickettsia lab. On January 14, 1977, Shepard and McDade isolated the agent that had caused the Legionnaires' disease outbreak. Legionnaires' disease continues to be a serious respiratory illness in developed countries. Although it can be treated with antibiotics, 11 percent of those who contract the disease die of the illness. There are an estimated 8,000 to 18,000 cases of Legionnaires' disease in the United States each year.

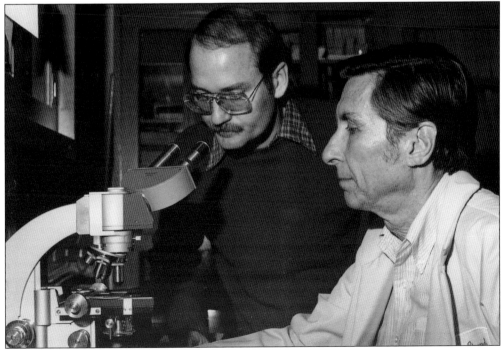

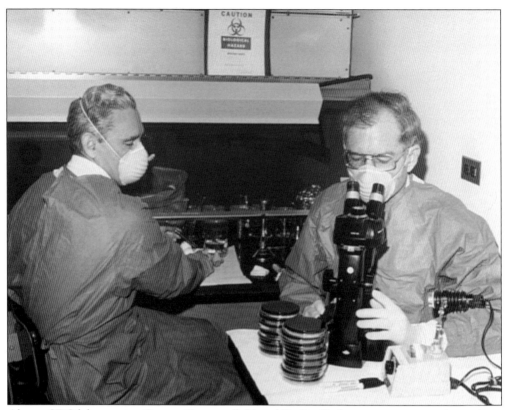

Above, CDC laboratorian George Gorman (left) and Dr. Jim Feeley are examining culture plates upon which the first environmental isolates of *Legionella pneumophila* had been grown. Feely and Gorman were the creators of the "F-G (Feely-Gorman) medium" that was used to harvest cultures of *L. pneumophila*, the pathogen responsible for causing Legionnaires' disease. On November 9, 1977, the Senate held a hearing (pictured below) on CDC's handling of the Legionnaires' disease outbreak. Seated at the table facing the Senate panel are, from left to right, CDC deputy director Dr. Walter Dowdle, CDC director Dr. William Foege, and Special Pathogens branch chief Dr. David Fraser. Members of the Senate panel included, among others, Sen. Edward M. Kennedy and Sen. Richard Schweiker.

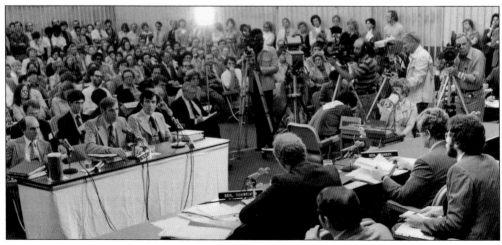

In the 1970s, CDC was caught up in the controversy caused by the *"Tuskegee Study of Untreated Syphilis in the Negro Male,"* commonly referred to as the Tuskegee Study. In 1932 (more than a decade before the formation of CDC), the US Public Health Service began working with the Tuskegee Institute to record the natural history of syphilis in hopes of justifying treatment programs for blacks. Researchers told the men they were being treated for "bad blood," a local term used to describe several ailments, including syphilis, anemia, and fatigue. In truth, they did not receive the proper treatment—even after antibiotics became available in the 1940s—to cure their illness. Although originally projected to last six months, the study went on for 40 years. In 1957, it was transferred to CDC, which ended the program in 1972 after people raised ethics concerns. This image shows Eunice Rivers, RN (second from right), with two colleagues in the 1950s visiting a patient (far right) in Alabama. Rivers was assigned to the study in 1932. Because she was the only staff member involved for all 40 years, her knowledge of the study was invaluable.

In the 1970s, CDC began in-depth research of sanitation in health care facilities. This sink has two elements that are often found to enhance the growth of bacterial colonies: bar soap that could become contaminated with bacteria and a faucet aerator that could collect and enhance the growth of water-borne microorganisms. By the 1990s, the Healthcare Infection Control Practices Advisory Committee (HICPAC), a federally appointed advisory committee, was assembled to provide advice and guidance to CDC regarding the practice of infection control and strategies for surveillance, prevention, and control of health care–associated infections, antimicrobial resistance, and related events in United States health care settings.

Two unidentified CDC public health advisors are shown working on a pilot project known as the Study on the Efficacy of Nosocomial Infection Control (SENIC) Project. This project, designed by Robert W. Haley, MD, measures the accuracy of a system that detects hospital-acquired infections through the analysis of medical records. SENIC was ultimately used to measure the change of infection rates in a random sample of United States hospitals. To this day, the SENIC Project is still the largest national study ever done by CDC, and it established the scientific basis for infection-control programs used in hospitals around the world.

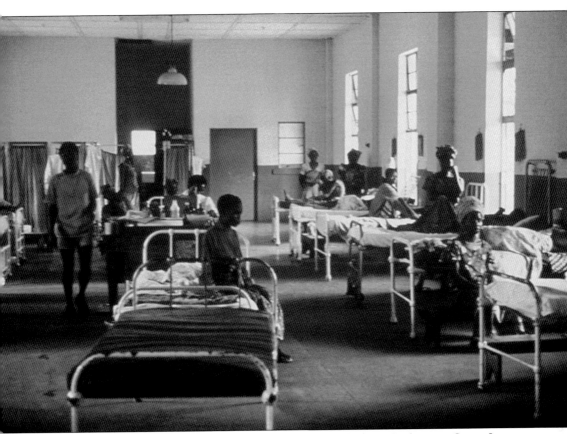

This is a hospital ward housing females affected by Lassa fever in Segbwema, Sierra Leone. In 1976, CDC traveled to Sierra Leone to participate in a Lassa Fever Research Project at the Kenema Laboratory and in Segbwema. The research project was specifically aimed at studying and developing treatment for Lassa fever. Sierra Leone had played a crucial role in the advancement of Lassa fever research since the mid-1960s. In 1979, there was a suspected outbreak of Lassa in the eastern province of Sierra Leone. The outbreak was centered in a Catholic missionary hospital in Pangama. It was apparent that this was not a typical outbreak, and only a small fraction of the cases could be traced to infection acquired in the hospital itself. In fact, most of the patients became infected in their own village. Dr. Aniru Monath, a Sierra Leone physician, along with scientists from CDC, Yale University, and the Ministry of Health of Sierra Leone, began a systematic study of animals from patients' homes to determine the carrier of the disease. Hundreds of animals, particularly rodents, were collected from the village and surrounding areas. Several strains of Lassa virus were isolated from a small gray rodent found living in the houses, implicating it as the reservoir host. Since this discovery, several other studies have been carried out in West African village settings confirming the transmission of Lassa virus to man from this common village rodent, Mastomys natalensis.

In 1972, the National Clearinghouse on Smoking and Health joined CDC. CDC director Dr. David Sencer welcomed the prevention agency and asked his staff to demonstrate their commitment to the work of the clearinghouse by banning smoking in classrooms, conference rooms, and elevators. This poster is an example of communication tools created to encourage people to not "get hooked" on smoking. The clearinghouse would ultimately become the Office on Smoking and Health (OSH), which is now the lead federal agency for comprehensive tobacco prevention and control; OSH is dedicated to reducing death and disease caused by tobacco use and exposure to secondhand smoke.

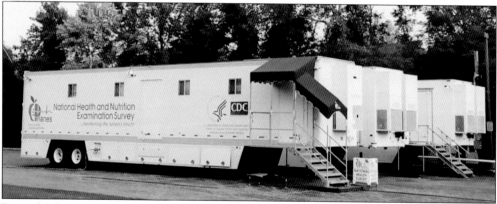

Beyond fighting infectious diseases, CDC began applying research to improve people's daily lives. One example of this is the National Health and Nutrition Examination Survey (NHANES), which is used to assess the health and nutritional status of adults and children in the United States and is responsible for producing health statistics for the nation. NHANES research illustrated the major role of nutrition in disease prevention.

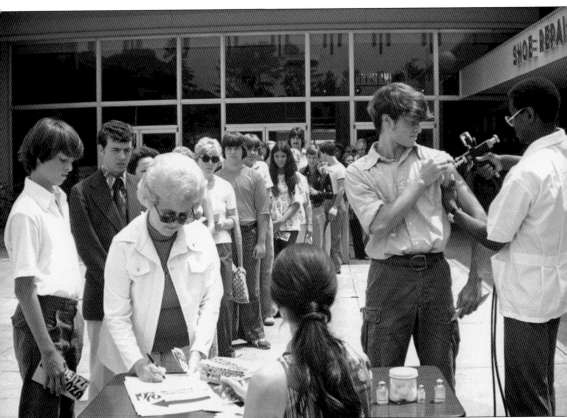

These people are awaiting influenza vaccinations in New Jersey in 1976. The image was captured during an immunization campaign for what became known as the swine flu. Note the jet injector being used to administer the vaccine. Swine flu is a respiratory disease caused by type A influenza viruses that regularly cause outbreaks of influenza in pigs. Swine flu viruses do not normally infect humans, but sporadic human infections with swine flu have occurred. During the 1976 swine flu scare, CDC coordinated the vaccination of 43 million people in two months (a mammoth task). However, CDC abruptly ended the effort when a few people who had received the vaccination developed Guillain-Barré syndrome, a rare disorder in which the body's immune system attacks the nervous system. The exact cause of Guillain-Barré syndrome is unknown, but it is often preceded by an infectious illness such as a respiratory infection or a stomach virus. In spite of this obstacle, the 1976 campaign had a positive outcome—the predicted swine flu epidemic never occurred.

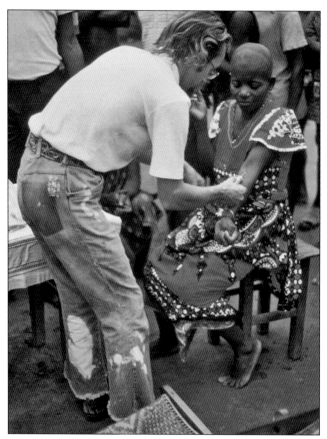

In the image at left, a member of an Ebola fever survey team extracts a blood sample from a resident in Zaire (now known as the Democratic Republic of Congo) during the 1976 outbreak. The outbreak started in the town of Yambuku and spread to surrounding areas. Within weeks, the deadly hemorrhagic disease had destroyed the small village (below). The total number of cases in Zaire was 318 with a mortality rate of 88 percent. By quickly isolating the disease, CDC and other disease control organizations prevented the spread of the Ebola virus beyond Yambuku and Western Sudan. Though Ebola was previously unknown until it was identified by CDC, evidence suggested that the "natural reservoir" of the Ebola virus is zoonotic (animal-borne) and maintained in an animal host native to the African continent.

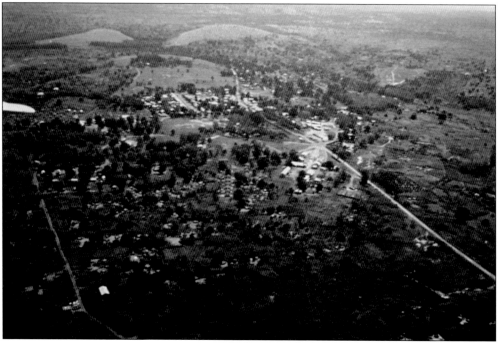

When conducting investigations of highly infectious diseases in the field, mobile quarantine facilities (MQFs) are vital to the safety of field personnel, as they allow them to handle specimens in the safest way possible by utilizing the facility's isolation compartment. CDC bought one such MQF, shown here in 1976, from the US Air Force Museum for $1. A C-141 jet can be used to transport the facility anywhere in the world during dangerous outbreaks.

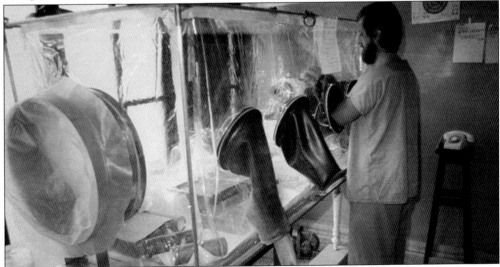

A CDC Epidemic Intelligence Service officer is shown during the 1976 Ebola outbreak in Zaire. The officer is working with a Vicker's Isolator, also known as the "Life Island," a portable plastic envelope that surrounds a hospital table or bed and is used to prepare specimens or isolate patients with highly infectious diseases. These units are transportable and isolate patients placed inside from the external environment. Health practitioners, such as EIS officers, had to be well protected from the Ebola virus. Exposure due to direct contact with the blood and/or secretions of an infected person can easily facilitate its spread from patient to treatment personnel.

A young man navigates floodwaters during a 1974 cholera research and nutrition survey in Bangladesh. Cholera, caused by the *Vibrio cholerae* bacterium found in brackish waters, infects humans through ingestion of contaminated water. In the mid-1970s, the CDC was called upon to utilize epidemiological principles to assist with cholera outbreaks in Bangladesh and Nepal.

A local health care volunteer is shown distributing rice to local Bangladeshi townsfolk during a time of famine. In the 1970s, Bangladesh was one of the poorest countries in the world. Participation in nutrition and family planning activities in other parts of the world during the 1970s, in addition to increased efforts to control infectious diseases, were characteristic of CDC's expanding role in international health.

This 1978 photograph shows Dr. Karl M. Johnson securing the zippered opening of a positive-pressure suit worn by his colleague, Dr. J.V. Lange, prior to entering one of CDC's early Maximum Containment Laboratories. Protective equipment has changed drastically over the years to help keep personnel even safer.

In 1973, CDC created the Alaska Investigations Program (AIP), based in Anchorage. AIP is an epidemiology/laboratory research unit of CDC's National Center for Infectious Diseases. It focuses on preventing infectious diseases in the widely scattered, sparsely distributed populations of the arctic and subarctic, especially Alaska natives. Studies focus on infant mortality, the epidemiology of cancer, foodborne botulism, and other public health issues common to Alaska natives.

The Three Mile Island nuclear power plant in Pennsylvania—the site of an accident on March 28, 1979—brought CDC to the forefront in its role as environmental watchdog for the nation. The accident was the most serious in domestic commercial nuclear power plant operating history, even though it led to no deaths or injuries to plant workers or members of the nearby community. Within hours of the accident, CDC teams were in place to create epidemiology and surveillance procedures, such as radiation measurement, and to put plans into place to evacuate the area if it was necessary. CDC efforts resulted in sweeping changes that impacted future emergency response planning, reactor operator training, human factors engineering, radiation protection, and many other areas of nuclear power plant operations.

Six

THE 1980S
THE GLOBAL VILLAGE IS INVADED BY AIDS

In the 1980s, CDC's name changed to Centers for Disease Control to reflect major organizational changes. After approximately 16 stand-alone federal health-related agencies were transferred to CDC, the agency established new branches and divisions.

The agency's focus began to expand, nationally and internationally, beyond infectious diseases. Its world-renowned epidemiologists and laboratorians were called upon to address growing challenges such as environmental health, chronic disease prevention, birth defects, cholesterol, exposure to chemical toxins, violence, injury control, and more, paving the way toward establishing CDC as the nation's premier disease prevention agency.

A plethora of new tasks ranged from standardizing immunization forms used in public schools to the creation of oligonucleotide mapping (fingerprinting of a virus) to development of cold boxes used to keep vaccines cold (especially beneficial in tropical locales), ever broadening the agency's contributions.

New public health issues that surfaced during this time included toxic shock syndrome and Agent Orange–related psychological and reproductive health issues facing Vietnam veterans. But one new, mysterious disease would profoundly affect the psyche of America and the "global village," providing the biggest challenge yet for CDC: acquired immunodeficiency syndrome, or AIDS.

Before AIDS, public fear of infectious disease had largely subsided due to the availability and extensive use of vaccines and antibiotics. But like a whisper in the night that began with a few isolated cases, the muffled noise soon evolved into a roar that would have implications around the world. AIDS quickly became a concern for every American, bringing with it devastating results and a list of ethical, medical, legal, and economic implications.

CDC helped lead the fight against the disease, including characterization of the syndrome and defining risk and prevention factors. After three decades, the battle rages on, but thanks to the efforts of CDC researchers and disease detectives, AIDS is now becoming more manageable thanks to the evolution of life-saving drugs, education of new generations, and ongoing surveillance of societal groups prone to contracting the disease.

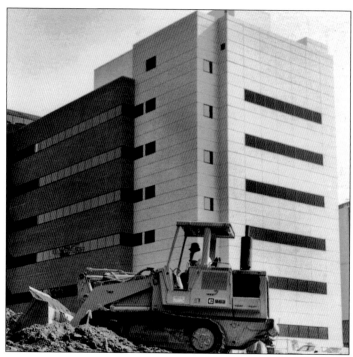

The 1980s were a period of both physical and organizational growth at CDC. Construction began on the Clifton Road campus, pictured here with the structure known as Building 15, the Viral and Rickettsial Diseases Laboratory. By 1981, the scope of CDC's work had expanded far beyond communicable diseases. Following extensive reorganization, "Center" became "Centers" as more health agencies joined the organization. The words "and Prevention" were added a decade later.

On June 5, 1981, the CDC published a *Morbidity and Mortality Weekly Report* describing cases of a rare lung infection, *Pneumocystis carinii pneumonia* (PCP), in five young, previously healthy gay men in Los Angeles. All the men had other unusual infections as well, indicating that their immune systems were not working; two had already died by the time the report was published. This edition of the MMWR marks the first official reporting of what would become known as the AIDS epidemic. (Photograph by Bob Kelley.)

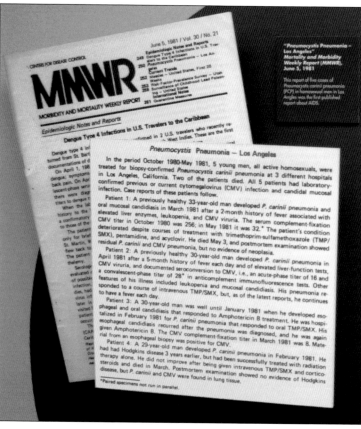

A scanning electron micrograph offers a microscopic view (above) of the human immunodeficiency virus, or HIV-1, cocultivated with human white cells or lymphocytes. The mysterious retrovirus, identified in 1983 as the pathogen responsible for AIDS, is characterized by changes in the population of T-cell lymphocytes that play a key role in the immune defense system. In an infected individual, the virus causes a depletion of T-cells, leaving patients susceptible to opportunistic infections. Dr. James W. Curran, former director of CDC's AIDS Task Force that conducted the initial investigations into AIDS, is pictured below in 1986. Curran held various AIDS leadership positions at CDC.

Since the start of the AIDS epidemic, CDC has been at the forefront of HIV investigation and lab research. In this 1983 image, CDC research chemist Rosemary Ramsey conducts chromatography tests on biological fluids from AIDS patients. Chromatography is the separation of a chemical mixture into its component compounds using a system designed to slow their passing based on properties such as size, charge, or composition.

Former Surgeon General Dr. C. Everett Koop is shown addressing CDC employees during a 1988 presentation. Dr. Koop advised the public on a variety of health matters, including smoking and health, diet and nutrition, environmental health hazards, and the importance of immunization and disease prevention. He also became the government's chief spokesman on AIDS.

CDC made public health history in 1988 by mailing a pamphlet entitled *Understanding AIDS* to every household in the United States. CDC distributed approximately 126 million copies, reaching at least 60 percent of the population. The campaign marked the first time the federal government had attempted to contact virtually every resident directly by mail about a major public health problem.

Early in the AIDS crisis, CDC realized the need to get educational and prevention information to the public, including individuals, businesses, schools, civic and volunteer groups, and religious organizations. CDC activated the National AIDS Hotline, which provided information around the clock in English, Spanish, and for the hearing impaired. Calls were free and confidential, and callers did not have to give their names to get their questions answered.

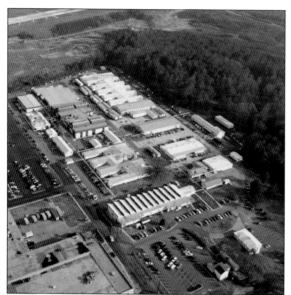

CDC's 50-acre Chamblee campus is shown in this aerial photograph from 1988. The old Quonset huts, converted Army barracks, and antiquated structures on the site were beginning to be replaced with specially designed laboratory buildings outfitted with the latest research equipment so that CDC's world-class scientists and technicians could do their best work.

Former president Jimmy Carter is shown speaking with laboratorians during a 1985 visit to CDC. In 1982, Carter and his wife, Rosalynn, founded The Carter Center with the goal of advancing human rights and alleviating unnecessary human suffering. In 1986, the Center's Guinea Worm Eradication Program began work against Guinea worm disease in Ghana; today, in partnership with CDC, it continues this important work.

A CDC Epidemic Intelligence Service officer is collecting water samples for laboratory analysis. The EIS, CDC's critical epidemiology training service, studies and combats the causes of major epidemics. EIS was instrumental in addressing major health issues in the 1980s, including field assistance with toxic shock syndrome, toxic oil syndrome, AIDS, and a case of intentional salmonella food poisoning in Oregon that became known as the first bioterrorist event in the United States.

An Epidemic Intelligence Service field assignment worker is shown investigating dengue fever, a mosquito-transmitted disease found in tropical climates. In the 1980s, CDC stepped up efforts to investigate and seek solutions to dengue. Today, 40 percent of the world's population lives in areas where there is a risk of dengue transmission. The disease is endemic in at least 100 countries in Asia, the Pacific, the Americas, Africa, and the Caribbean. Nearly all dengue cases reported in the 48 continental states were acquired elsewhere by travelers or immigrants.

In the late 1970s, the federal government declared a state of emergency in Love Canal, New York, after the discovery of toxic chemicals at a local dump site. CDC, along with the Environmental Protection Agency (EPA), participated in a cytotoxicity study on local residents as part of the ensuing investigation. This photograph was taken during cleanup efforts. As a result of the incident, Congress passed the Comprehensive Environmental Response, Compensation, and Liability Act (CERCLA) in 1980 to address the dangers of abandoned or uncontrolled hazardous waste dumps. CERCLA also created a new entity to protect public health from hazardous waste and environmental spills of hazardous substances: the Agency for Toxic Substances and Disease Registry (ATSDR). It took five years before ATSDR opened for service in 1985. Its responsibilities include public health assessments, establishment and maintenance of toxicological databases, information dissemination, and medical education. Although ATSDR is an independent operating division within the US Department of Health and Human Services, CDC assists in investigations and performs many of the administrative functions for ATSDR.

Graphic designers and medical illustrators are often asked to create visual aids to accompany television broadcasts, slide presentations, and textual documents that assist in CDC's mission to promote public health awareness. From its inception, CDC has always recognized the need to consistently remind the public to take preventative measures. This poster tapped into the popular culture of the 1980s by using *Star Wars* characters to remind people of the importance of immunization. (National Library of Medicine.)

This mid-20th-century image shows the polluted waterfront landscape of an American city. In the 1980s, increased emphasis on environmental health based on CDC recommendations helped federal, state, and local governments forge the rules and regulations that industry must abide by in order to stem environmental damage caused or created by industrial pollution. Today, industrial plant exhaust stacks are outfitted with filtration devices that dramatically reduce the expulsion of air pollutants into the atmosphere.

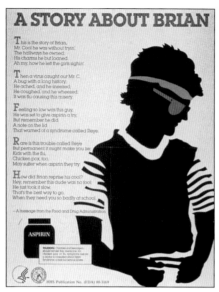

Reye's syndrome is a severe neurologic disorder that develops almost exclusively in children and teenagers. Although Reye's is rare today, 30 years ago it commonly arose during or after outbreaks of influenza or chickenpox. CDC conducted a groundbreaking study that focused attention on the problem of Reye's and a possible connection with aspirin. As a result, in 1986, the Food and Drug Administration required a Reye's syndrome–related warning label for all medications containing aspirin. (National Library of Medicine.)

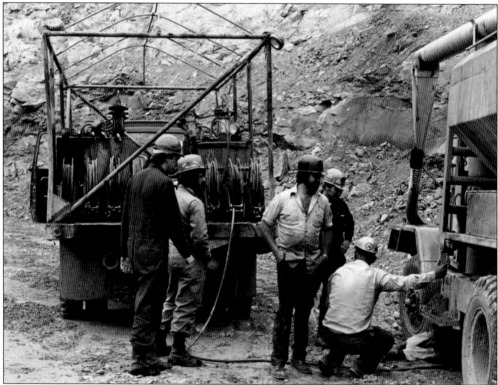

Workers at a stone quarry are pictured here during a National Institute for Occupational Safety and Health exposure assessment project. Since the 1970s, NIOSH has conducted research in order to make recommendations for the prevention of work-related injuries and illnesses. In 1983, NIOSH published a suggested list of "Ten Leading Work-Related Diseases and Injuries," including "fractures, amputations, eye losses, and traumatic deaths." NIOSH established a task force to develop a strategy for the control of traumatic injuries (TI); this was the first national-level strategy for addressing TI by means of research and prevention activities.

In the summer of 1980, Americans reported a number of cases of toxic shock syndrome (TSS), a serious and potentially fatal disease caused by a bacterial toxin. As part of the quickly formed Toxic Shock Syndrome Task Force, CDC efforts discovered that users of a particular brand of tampons were at increased risk for developing TSS. As a result, that brand was immediately withdrawn from the marketplace. (National Library of Medicine.)

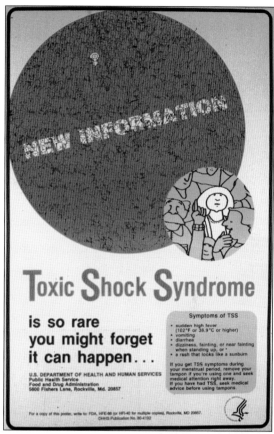

Mount St. Helens, located south of Seattle, Washington, erupted on May 18, 1980, and became the epicenter of an earthquake measuring 5.1 on the Richter scale. The north face of this tall, symmetrical mountain collapsed in a massive avalanche. CDC, which was becoming more and more involved in assisting in the aftermath of natural disasters, funded and conducted a series of studies on the health effects of the eruption, including the consequences of dust inhalation.

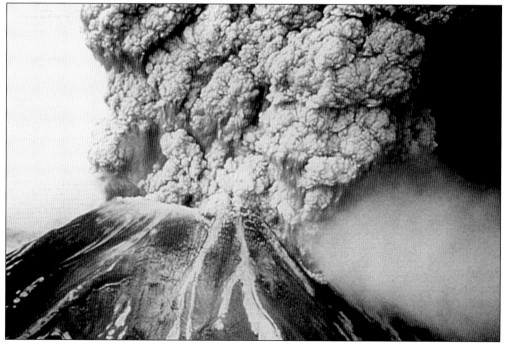

Late in the evening on September 21, 1989, the eye of Hurricane Hugo struck the coast of South Carolina near Charleston. Winds of 135 mph, a tidal surge of 12 to 17 feet, and heavy rains killed dozens of people and caused $7 billion in damage. CDC personnel arrived to assist with communicable disease and safety issues. The availability of safe food and water, health care services, and sanitation facilities; the degree of crowding; and the underlying health status of the population all influence the risk of communicable diseases and death in the affected population.

Seven

THE 1990S
CDC BECOMES A GLOBAL FORCE

By the beginning of the 1990s, CDC's role had expanded far beyond communicable diseases. More and more significance was being placed on addressing an expanded variety of public health issues and providing responses to global health issues. In October 1992, Congress changed CDC's official name to Centers for Disease Control and Prevention in recognition of its growing leadership role in prevention. To maintain the agency's established identity, it legally retained the "CDC" acronym.

CDC now placed emphasis on applying classic field-oriented epidemiology to important domestic challenges including air pollution, birth defects, childhood lead poisoning, safe drinking water, youth and domestic violence, and developmental disabilities such as Down syndrome. CDC research and epidemiology research had provided significant guidelines related to the prevention of AIDS and HIV, and infections began to drop significantly by the middle of the decade after the introduction of highly effective antiretroviral drug therapies.

New emerging disease challenges worldwide needed to be addressed on an even more widespread basis. These included hantavirus, avian flu, West Nile virus, and new outbreaks of the Ebola virus. In the wake of national and international tragedies such as the Oklahoma City bombing, the sarin gas subway attacks in Tokyo, and 1993's first attempted bombing of the World Trade Center, CDC took the lead in responding to acts of bioterrorism. This role later reached its pinnacle in 2001 at the World Trade Center and Pentagon.

After a serious food poisoning incident in 1993, CDC scientists performed laboratory tests and determined that a specific strain of E. coli found in the victims was the same strain found in hamburgers. Looking for a way to recognize foodborne outbreaks more quickly, the CDC worked with the Association of Public Health Laboratories (APHL) to develop a shared computer network, PulseNet. Since 1996, PulseNet has connected foodborne illness cases by using DNA "fingerprinting" of the bacteria in order to detect and define outbreaks.

In the wake of floods, famines, tornadoes, and hurricanes, CDC teams offered disaster assistance to many nations and across the United States in the 1990s. These included Hurricane Andrew in Florida in 1992, flooding throughout the United States and Alaska, an earthquake in California in 1994, plus earthquakes, hurricanes, eruptions, and flooding that occurred worldwide.

By the dawn of the 21st century, the combined triumphs, research, and surveillance efforts of CDC's first 50 years had earned it a reputation as the nation's premier prevention agency and a global leader in public health.

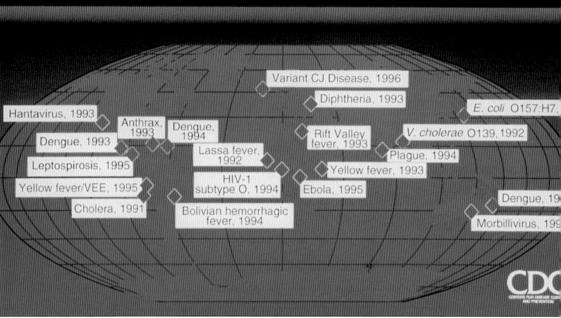

Global Microbial Threats in the 1990s

Variant CJ Disease, 1996
Diphtheria, 1993
E. coli O157:H7,
Hantavirus, 1993
Anthrax, 1993
Dengue, 1994
Rift Valley fever, 1993
V. cholerae O139, 1992
Dengue, 1993
Lassa fever, 1992
Plague, 1994
Leptospirosis, 1995
Yellow fever, 1993
Yellow fever/VEE, 1995
HIV-1 subtype O, 1994
Ebola, 1995
Dengue, 19
Cholera, 1991
Bolivian hemorrhagic fever, 1994
Morbillivirus, 199

CDC
CENTERS FOR DISEASE CONTROL AND PREVENTION

To microorganisms, the world is a global village without borders. In the 1990s, population explosions brought expanded poverty and urban migration, international travel and commerce reached new proportions, and rapidly changing technology increased the risk of exposure to infectious diseases. Working in partnership with health departments, federal agencies, public health professionals, and international organizations, CDC vigorously expanded its global outlook during this decade to address emerging disease threats. To do so efficiently, the agency did what it had been doing so well for decades—created a strategic plan to meet emerging challenges. The plan contained four goals: surveillance, applied research, prevention and control, and improving public health infrastructure. For CDC to help control an epidemic on foreign soil, three things must happen: reliable information needs to be received, scientists and epidemiologists have to evaluate the information and decide what measures need to be taken, and CDC must receive a formal request for assistance from the foreign government. If no request is received, CDC will still take action to minimize the risk of the disease entering the United States.

Since West Nile virus (WNV) was discovered in the United States in 1999, the arbovirus has been detected in over 300 species of birds. It is transmitted to birds and humans through the bite of infected mosquitoes. The study of bird-based arbovirus infections is important because birds serve as the vertebrate reservoir hosts in the transmission cycle of numerous arboviruses, including WNV. Since 1999, over 37,000 cases of WNV have been reported to CDC, with an estimated cost of $778 million in health care expenditures and lost productivity. This bird was captured and later tested during an arbovirus study.

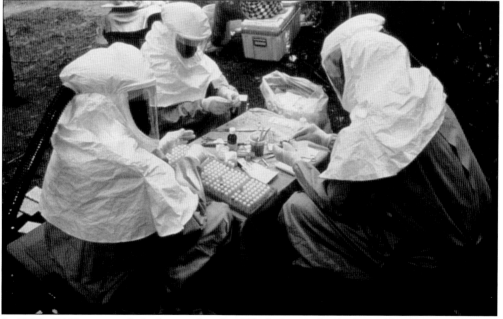

In 1995, CDC was notified of an outbreak of Ebola hemorrhagic fever–like illness in Kikwit, Zaire (now Democratic Republic of Congo). As a result, CDC and local agencies implemented surveillance for possible cases of Ebola using a new diagnostic test for the virus (developed by CDC) at 13 clinics in Kikwit and 15 remote sites within a 150-mile radius of the city. CDC and Zairian scientists are shown here taking samples from animals suspected of being natural reservoirs of the virus. Natural reservoirs of the Ebola virus remain unknown, but fruit bats appear to be one of the likely hosts.

By the 1990s, most vaccine-preventable childhood diseases were at or near their lowest reported levels. However, CDC experts declared that decreases in disease burden could only be sustained by achieving and maintaining high vaccination levels among children two and younger. In 1993, CDC established the National Immunization Program to increase momentum toward higher immunization. The next year, the agency launched a long-term national outreach campaign to improve awareness of the need for timely childhood vaccination.

By the 1990s, antibiotics had been in civilian use for over 50 years. Surveillance studies at CDC began to show the emergence of drug resistance in many organisms. In 1992, about 13,300 hospital patients died of bacterial infections that were resistant to antibiotic treatment. It became apparent to CDC experts that efforts needed to be made to combat this problem, including improving infection control, developing new antibiotics, and using drugs more judiciously.

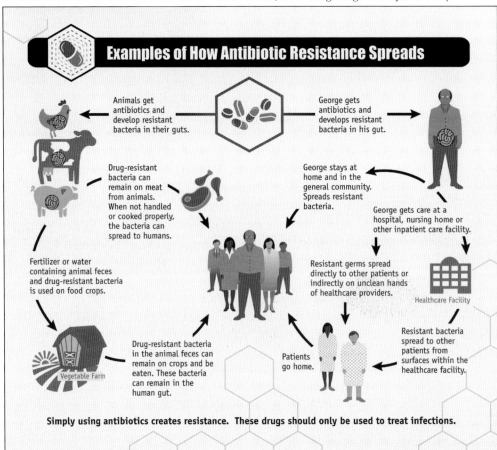

Examples of How Antibiotic Resistance Spreads

Animals get antibiotics and develop resistant bacteria in their guts.

George gets antibiotics and develops resistant bacteria in his gut.

Drug-resistant bacteria can remain on meat from animals. When not handled or cooked properly, the bacteria can spread to humans.

George stays at home and in the general community. Spreads resistant bacteria.

George gets care at a hospital, nursing home or other inpatient care facility.

Fertilizer or water containing animal feces and drug-resistant bacteria is used on food crops.

Resistant germs spread directly to other patients or indirectly on unclean hands of healthcare providers.

Healthcare Facility

Resistant bacteria spread to other patients from surfaces within the healthcare facility.

Drug-resistant bacteria in the animal feces can remain on crops and be eaten. These bacteria can remain in the human gut.

Vegetable Farm

Patients go home.

Simply using antibiotics creates resistance. These drugs should only be used to treat infections.

CDC increased the emphasis on environmental health during the 1990s to help prevent adverse human health effects and diminished quality of life associated with exposure to hazardous substances from waste sites, unplanned releases, and other sources of pollution in the environment. CDC conducted public health assessments, health studies, surveillance activities, and educational training at waste sites. This hazmat technician is analyzing the contents of a potentially environmentally toxic site while wearing a protective suit.

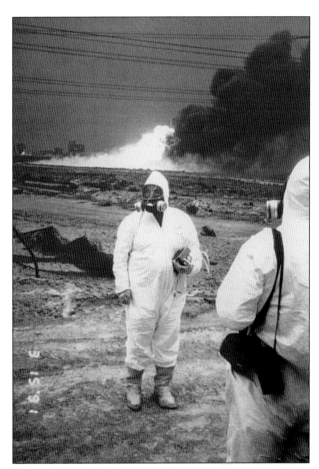

This slum in Ecuador was heavily affected by cholera in 1992 due to its proximity to unsafe water sources. Epidemic cholera had been absent from South America for nearly a century before it was introduced into Peru in January 1991. By 1996, more than one million cases of cholera had been reported in the region, and area governments asked CDC to conduct outbreak investigations and provide epidemiological assistance.

The 1993 *Surgeon General's Report for Kids* (SGR4KIDS) outlined the harmful truth about smoking. The inaugural 1993 report focused on smoking and its effects on children. Surgeon General Dr. Joycelyn Elders posed on the cover of the report with a group of children. In 1994, CDC's National Center for Environmental Health (NCEH) determined a relationship between women's exposure to environmental tobacco smoke (ETS) and their risk of having babies with low birth weight.

Launched in 1994, CDC's Office of Women's Health (OWH) demonstrates the agency's commitment to preventing unnecessary disease and death among women in the United States and abroad. The office provides funds for educational projects addressing breast and cervical cancer, osteoporosis, HIV infection, STDs, and violence against women. Other priorities include promoting reproductive health and health in later years. OWH's work helps educate women on the importance of using preventative measures such as mammograms (pictured) to control and prevent the onset of chronic diseases such as breast cancer.

The National Center for Injury Prevention and Control was formed in 1992 to address nonoccupational injuries and injuries that result from violence. Epidemiologic investigations done by CDC for the infamous Atlanta Child Murders case in the 1980s proved that the same type of research often used to address public health issues (surveillance, risk factor identification, intervention, and evaluation) could successfully be applied to acts of violence and unintentional injuries.

The History of Violence
AS A PUBLIC HEALTH ISSUE

CDC

Although chronic diseases are among the most common and costly of all health problems, they are also among the most preventable. Using data from the fledgling National Center for Chronic Disease Prevention and Health Promotion, created in 1988, CDC researchers and epidemiologists entered the 1990s vigorously seeking new ways to prevent and control chronic diseases. These heightened efforts targeted chronic diseases such as diabetes, lung disease, kidney disease, heart disease and stroke, high blood pressure and cholesterol, smoking, cancer, arthritis, and obesity.

The Messengers
Lameck Bonjisi (1973-2003)
Serpentine stone

The Messengers is an example of Shona sculpture, reflecting traditional and contemporary Zimbabwean culture. The intention of the artist was to honor his ancestors and to represent the strength of families. CDC has chosen the work as a symbol of this facility's mission—to educate all who visit about the interplay of public health, culture, and community.

A special exhibition area located at CDC headquarters in Atlanta is home to the David J. Sencer CDC Museum. The 19,000-square-foot venue recalls CDC's accomplishments with battling polio, malaria, Legionnaires' disease, and other major diseases; it also shows visitors how CDC's work touches everyday life and the role individuals can play in preventing disease and injury. The entrance to the museum is home to a dramatic sculpture, *The Messengers* (pictured), by Zimbabwean artist Lameck Monjisi, who died of AIDS in 2003. The statue is an example of Shona sculpture that reflects traditional and contemporary Zimbabwean culture. Nearly 100,000 people visit the museum annually, and admission is free. Known as the Global Health Odyssey Museum when it opened in 1996, CDC changed the name in 2011 to honor Dr. Sencer, the longest-serving director of the CDC and a great believer in the importance of preserving CDC history. Under his leadership, CDC dramatically expanded, adding global and domestic programs that addressed issues ranging from malaria and disaster relief to reproductive health and tobacco control.

A 100-foot-long multimedia installation incorporating eight enormous screens (below) greets guests at the CDC Museum. Titled *Global Symphony*, the display offers insight into the world of CDC and public health. The presentation is peppered with media clips and sound bites on public health topics ranging from HIV and AIDS to worker safety. A leisurely stroll through the museum provides visitors with highlights from CDC's historic past (such as the transmission electron microscope at right), and temporary exhibits have included topics like practical design elements for shelter, cooking, clean water for people without basic resources, health as a human right, and artwork by children impacted by the 9/11 attacks.

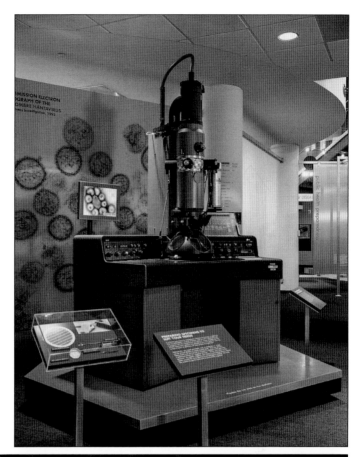

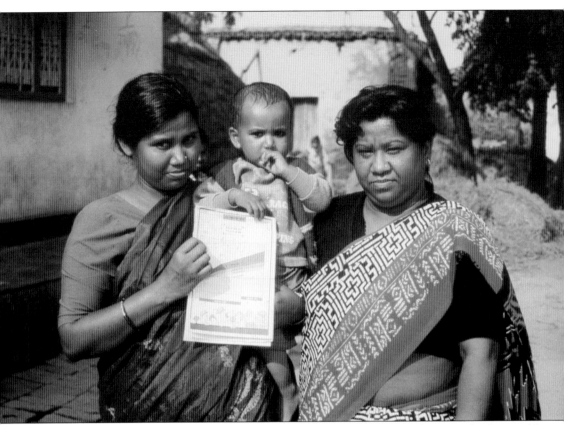

CDC increased emphasis on global health and immunization efforts in the 1990s for diseases like polio. Although virtually eliminated in the United States, polio was still a problem around the world, and this provided the impetus for the creation of the Stop Transmission of Polio (STOP) program in 1998. The first STOP team had 25 participants, all of whom were CDC staff members. STOP participants worked primarily to strengthen surveillance efforts, support national immunization days, and conduct polio case investigation and follow-up reporting. Here, a mother in the state of Uttar Pradesh, in northern India, holds her child while displaying a polio vaccination record indicating that the child has been properly vaccinated. At right is the local health care practitioner who made rounds from house to house in order to conduct interviews to see whether children had or had not been properly vaccinated. Over the years, CDC expanded the program to include supporting measles mortality reduction and strengthening routine immunization activities. Today, the Global Polio Eradication Initiative is led by national governments in partnership with the World Health Organization, Rotary International, CDC, the United Nations Children's Fund (UNICEF), and the Gates Foundation.

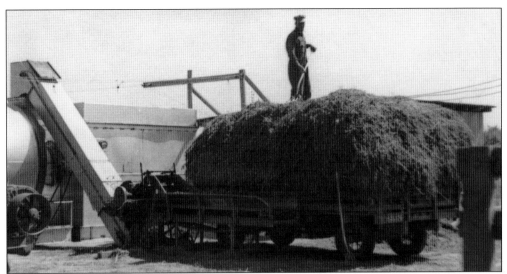

The Centers for Agricultural Disease and Injury Research, Education, and Prevention work to protect the health and safety of agricultural workers and their families. The NIOSH Agricultural Centers were established as part of a CDC/NIOSH Agricultural Health and Safety Initiative in 1990 to conduct research, education, and prevention projects to address the nation's growing agricultural health and safety problems. The centers are distributed throughout the nation in order to allow for responding to agricultural health and safety issues unique to the different regions.

While wearing a protective mask, this worker takes wet paint scrapings in a 1999 exercise demonstrating an exterior renovation method typically used on residences where lead-based paint was present. The exercise was conducted in order to assess workers' risk for lead exposure inherent in performing various tasks. Note that this worker is appropriately attired to avoid skin or inhalation exposure to possibly dangerous airborne particles.

An outbreak of hantavirus pulmonary syndrome (HPS) in the southwestern United States in the summer of 1993 was caused by a previously unrecognized hantavirus in which the deer mouse was the primary host. Another strain of hantavirus, Black Creek Canal virus, was isolated in cotton rats in Florida. CDC's focus on the reservoir species of the virus was the first step in designing effective strategies for control. Rodent infestation in and around the home remains the primary risk for hantavirus exposure. CDC collaborated with the National Park Service to study different methods of rodent control. The results of this partnership placed emphasis on making dwellings rodent-proof and modifying the environment around houses to make them less desirable for rodents. Here, three CDC health officials inspect specimens suspected of being connected with a hantavirus outbreak.

Eight

THE 2000S
A NEW CENTURY WITH
NEW CHALLENGES

By the arrival of the new millennium, CDC's scientists and staff had built a reputation far beyond that of the small wartime agency created to fight malaria 50 years earlier. CDC's pioneering success regarding a multitude of monumental health issues had earned the agency worldwide name recognition.

The agency's complex mission expanded even more with the dawn of the 21st century. Beyond building on existing research and addressing sporadic outbreaks of viral diseases, CDC became even more focused on prevention research, addressing issues such as tobacco use, obesity, diabetes, family planning, youth violence, and safe water and better sanitation in third-world countries. CDC was poised to not only continue fighting existing health issues but also to face challenges such as SARS, H1N1 influenza, Ebola and other new infectious diseases, bioterrorism, chronic diseases, and environmental hazards.

Today, CDC continues to play an important role in helping the nation and the world prepare for and respond to all types of health threats, including emergencies and natural disasters. In the aftermath of September 11, 2001, CDC first responders were there to gather surveillance data and monitor symptoms of disease and injuries among responders, cleanup workers, residents, office workers, schoolchildren, and others in the Manhattan area. In the days and months following the attack, CDC worked with the New York Department of Health on a wide range of health issues. With help from CDC advisors, the local health department was able to quickly address public health measures such as sanitation, monitoring food and water supplies, and using surveillance programs to protect citizens from infectious diseases.

Since its inception, CDC has recognized the value of working with countless health and philanthropic entities—too numerous to name here—to solve global health problems.

The CDC Foundation, an independent nonprofit organization, assists CDC by forging effective partnerships worldwide to help fight threats to health and safety. Since 1995, the CDC Foundation has provided $400 million to support CDC's work, launched more than 700 programs around the world, and built a network of individuals and organizations committed to supporting CDC and public health.

To summarize the overall contribution this invaluable government agency has made and continues to make, one need look no further than its mission statement:

> CDC works 24/7 to protect America from health, safety and security threats, both foreign and in the United States. Whether diseases start at home or abroad, are chronic or acute, curable or preventable, human error or deliberate attack, CDC fights disease and supports communities and citizens to do the same.
>
> CDC increases the health security of our nation. As the nation's health protection agency, CDC saves lives and protects people from health threats. To accomplish our mission, CDC conducts critical science and provides health information that protects our nation against expensive and dangerous health threats, and responds when these arise.

CDC's newly constructed headquarters building (left) opened in 2005. On July 12, 1999, the CDC campus, located near Emory University, was dedicated to former Congressman Edward R. Roybal of California for his outstanding service to public health. During his congressional term, Congressman Roybal spearheaded the funding for every new CDC building constructed between 1982 and 1992. In 2012, construction was completed on a 10-year project that included improvements to both the Roybal and Chamblee (below) campus sites. The project addressed overcrowding and antiquated facilities. The cost to design, construct, equip, and maintain the building and renovation project was approximately $1 billion.

New 21st century technology is helping CDC scientists do their jobs even more efficiently. Here, a CDC computer technology specialist holds a square-shaped gene sequencing computer chip designed to speed up the processes involved in the identification of viral DNA, finishing a process that formerly took months to accomplish in a period of three hours.

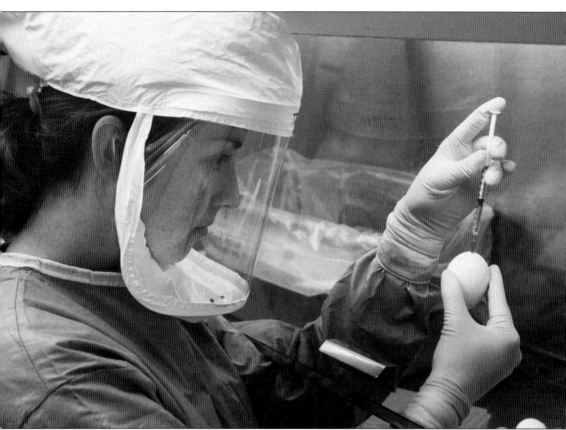

A microbiologist in CDC's Influenza Branch conducts an experiment inside a biological safety cabinet (BSC) within the Biosafety Level 3–enhanced laboratory. The scientist was inoculating 10-day-old embryonated chicken eggs with a specimen containing an H5N1 avian influenza virus. This experiment was part of a study to investigate the pathogenicity and transmissibility of newly emerging H5N1 viruses that will help in the early identification of H5N1 viruses with pandemic potential.

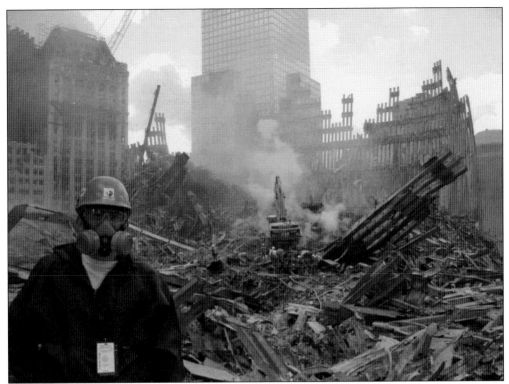

When the World Trade Center and Pentagon attacks occurred on September 11, 2001, CDC quickly moved to respond to the terrorist attacks by activating its Director's Emergency Operations Center (DEOC) and utilizing Epidemic Intelligence Service personnel. In the days following the attacks, EIS investigators established a syndromic surveillance system among 15 hospitals in Manhattan and in areas around the Pentagon, watching for signs of possible secondary or infectious diseases and the effects of dust and other health-threatening materials on residents and rescue workers.

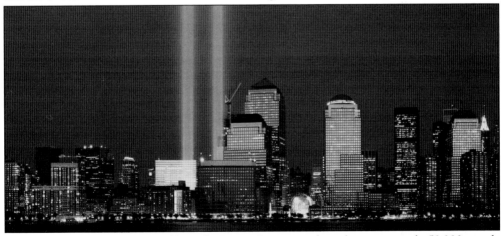

In 2002, CDC funded the World Trade Center Registry, a list of approximately 50,000 people who had some kind of exposure to the toxic chemicals that coated lower Manhattan after the towers fell. CDC, through its National Institute for Occupational Safety and Health, continues to monitor the physical and mental health status of these individuals, and they will do so for up to 20 years. (June W. Sobrito/Dreamstime.com.)

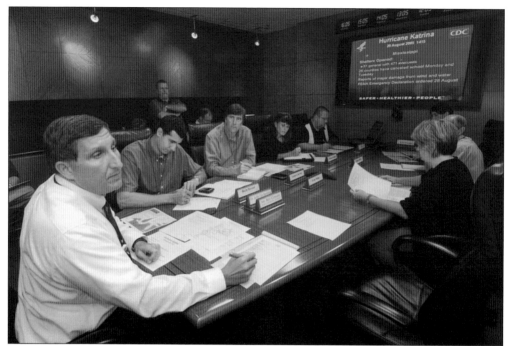

At a CDC Hurricane Katrina planning meeting held on August 29, 2005, public health officials are shown outlining CDC's response to the disaster, including the deployment of hundreds of employees to affected areas. Those deployed worked to support the affected states' public health response. CDC worked under the coordinating leadership of the Federal Emergency Management Agency (FEMA), part of the Department of Homeland Security, in order to meet the requests of affected states and address the most pressing needs.

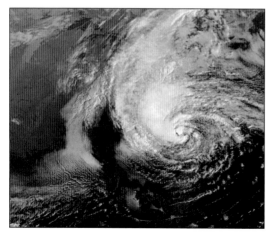

A satellite image shows "Superstorm Sandy," the deadliest and most destructive hurricane of the 2012 Atlantic hurricane season. Sandy made landfall as a post-tropical cyclone along the coast of southern New Jersey in late October. In the wake of its landfall, natural hazards associated with the storm—high winds, heavy rains, dangerous storm surge and flash flooding, snow, and cold weather—affected many areas. CDC's assistance focused on illness, injury, carbon monoxide poisoning, access to clean food and water, safe cleanup of mold, and other environmental concerns.

A CDC staff microbiologist is shown in 2005 analyzing reconstructed 1918 pandemic influenza virus. The 1918 Spanish flu epidemic was caused by an influenza A (H1N1) virus and killed up to 50 million people worldwide. The virus was re-created in order to identify the characteristics that made it such a deadly pathogen. Research efforts like this enable CDC scientists to develop new vaccines and treatments for future pandemic influenza viruses. H1N1 viruses still circulate today after being reintroduced into the human population in the 1970s.

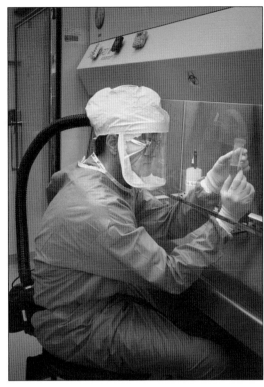

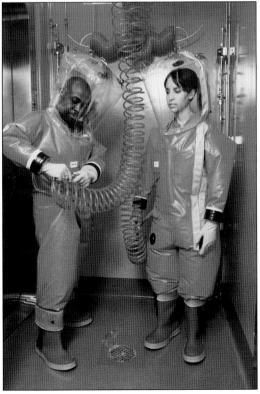

CDC Special Pathogens Branch (SPB) microbiologists suit up to enter a Biosafety Level-4 (BSL-4) laboratory in 2007. The scientist on the left is attaching his supportive air hose, which provides a supply of filtered, breathable air and helps maintain positive air pressure inside his airtight suit. BSL-4 viruses are highly pathogenic and require handling in special laboratory facilities designed to contain them. SPB focuses primarily on viral hemorrhagic fevers such as Ebola, Lassa fever, and hantavirus pulmonary syndrome.

Fire and emergency response personnel are shown practicing techniques for the containment and removal of hazardous materials. CDC has addressed threats of bioterrorism since the Cold War in the early 1950s and now works with state and local health departments to safeguard communities from public health threats. CDC's Office of Public Health Preparedness and Response leads response activities by providing strategic direction, support, and coordination for activities across CDC, as well as with local, state, tribal, national, territorial, and international public health partners.

CDC's Strategic National Stockpile (SNS) has large quantities of medicine and medical supplies to protect the American public in case of a public health emergency, such as terrorist attacks, flu outbreaks, and earthquakes severe enough to cause depletion of local supplies. The stockpiles are strategically placed across the nation so they can be delivered to any state in time for them to be effective. Each state has plans to receive and distribute SNS medicine and medical supplies to local communities as quickly as possible.

Haiti suffered devastating structural damage in the aftermath of a deadly 2010 earthquake. Transported to Haiti by the naval vessel USS *Bataan,* CDC public health teams provided humanitarian assistance and disaster relief support to Haiti following the earthquake, which measured 7.0 on the Richter scale. The teams worked through the chaos to help prevent outbreaks of diseases such as malaria, tuberculosis, cholera, and dysentery in hundreds of camps for displaced people around the city. (David Snyder/CDC Foundation.)

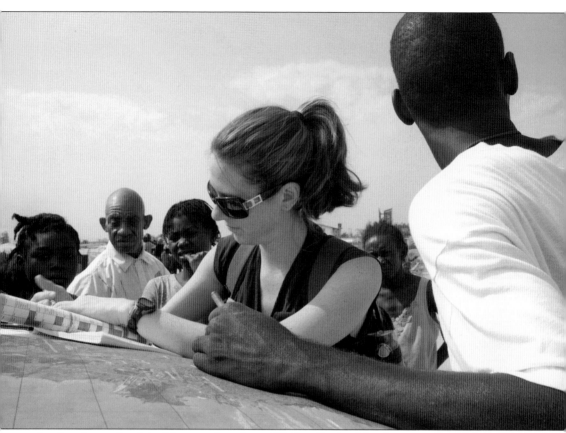

In the aftermath of the Haiti earthquake, a CDC public health advisor is seen using a Google Earth map while conducting disease surveillance in Port-au-Prince. The technology allowed CDC staff to compile real-time data about where people were gathering, which areas were most at risk for disease outbreaks, and where personnel and supplies should be directed. (David Snyder/ CDC Foundation.)

A Stop Transmission of Polio (STOP) program team member stands by as a clinic worker administers an oral polio vaccine to a child during one of India's National Immunization Days in 2000. The STOP program, created in the 1990s, is a global effort that trains public health professionals from around the world and sends them to places with the greatest need. The global effort to eradicate polio is the largest public health initiative in history.

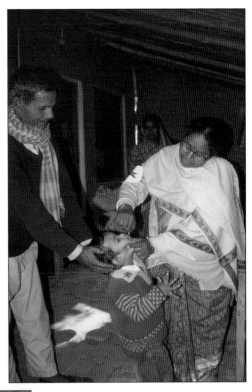

An electron microscope photograph shows the virus responsible for Severe Acute Respiratory Syndrome (SARS), first discovered in Asia in February 2003. The outbreak lasted approximately six months and spread to more than 24 countries in North America, South America, Europe, and Asia before it was stopped in July 2003. A SARS-like virus was isolated the next year from civets (mammals with a catlike body and a masked face) captured in areas of China where the SARS outbreak originated. CDC banned the importation of civets in 2004.

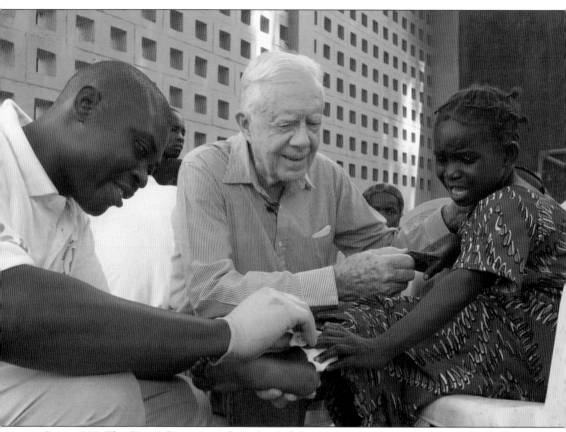

Since 1986, The Carter Center in Atlanta has led the international campaign to eradicate Guinea worm disease by working closely with ministries of health and local communities, CDC, the World Health Organization, UNICEF, and many others. When the Guinea Worm Eradication Program began, there were approximately 3.5 million cases crippling millions of people in 21 countries in Africa and Asia. Today, that number has been reduced by more than 99.9 percent. In 2013, approximately 148 cases of Guinea worm disease were reported worldwide, with the vast majority in South Sudan. Here, former US president Jimmy Carter comforts six-year-old Ruhama Issah at Savelugu (Ghana) Hospital in 2007 as a Carter Center technical assistant dresses Issah's extremely painful Guinea worm wound. In May 2010, with Carter Center support, Ghana reported its last case of Guinea worm disease. Guinea worm disease is on track to become the second human disease in history to be eradicated (the first was smallpox). If these efforts are successful, it will be the first parasitic disease to be eradicated and the first disease to be eradicated without the use of a vaccine or medicine. (The Carter Center/L. Grubb.)

A Sudanese girl is pictured in 2002 using a pipe filter to drink water gathered from a local pond. Similar to straws, pipe filters are individual filtration devices that allow people to filter drinking water in order to avoid contracting Guinea worm disease while traveling or working in the field. To prevent possible infection, all drinking water must be filtered in endemic areas to remove the microscopic copepods, or "water fleas," that carry the infective Guinea worm larvae. (The Carter Center/E. Staub.)

This photograph shows the emergence of a female Guinea worm from a sufferer's leg. Before the white, spaghetti-like worm emerges, a blister develops on the skin. This blister causes a very painful burning sensation and eventually ruptures. Once the worm emerges from the wound, it can only be pulled out a few centimeters each day and wrapped around a small stick or piece of gauze. Sometimes the worm can be completely removed within a few days, but the process often takes weeks. (The Carter Center.)

Milled wheat and maize flour (left) fortified with iron, folic acid, vitamin B12, vitamin A, and zinc is shown in storage at the Ocrim Flour Mill (below) in Manaus, Brazil. This fortification process is a safe and economical way to prevent birth defects and improve the health of local populations. The Flour Fortification Initiative, utilizing a network of partners (including CDC), has set a goal of making flour fortification a standard milling practice worldwide. CDC provides technical assistance in scientific issues related to fortification and best practices related to monitoring fortification programs for quality and impact. (David Snyder/CDC Foundation.)

When a disaster occurs, CDC must respond effectively to support national and international public health emergency response partners. A critical component of CDC's work during a public health emergency is coordinating response activities and providing resources to state and local public health departments. CDC's Emergency Operations Center (EOC)—a 7,000-square-foot facility that has 85 workstations that can support over 100 CDC personnel—is ground zero for response activities. The EOC also houses numerous conference and breakout rooms that allow for the coordination of simultaneous efforts. In the EOC, multimedia capabilities are combined with around-the-clock staffing to translate and decipher data from multiple sources. The facility is managed by CDC's Office of Public Health Preparedness and Response, Division of Emergency Operations. (David Snyder/CDC Foundation.)

CDC's Office of Public Health Preparedness and Response provides strategic direction, support, and coordination with local, state, tribal, national, territorial, and international public health partners. Here, a quarantine officer enters a plane in order to assess the status of an ill traveler during a 2008 preparedness exercise involving CDC and a number of federal and local agencies. CDC plays a critical role in national and global preparedness because of its unique expertise in responding to infectious, occupational, or environmental incidents.

Ebola hemorrhagic fever is a severe, often fatal disease in humans and nonhuman primates that has appeared sporadically since it first surfaced in 1976. The disease is caused by infection with the Ebola virus, which is named after a river in Zaire (now Democratic Republic of Congo) close to where it originated. A severe outbreak in West Africa beginning in March 2014 created increased global awareness of the virus and prompted the acceleration of a potential vaccine. This scanning electron micrograph (SEM) offers a microscopic view of the Ebola virus.

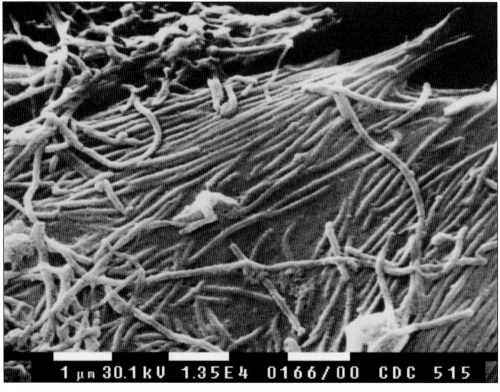

1 µm 30.1kV 1.35E4 0166/00 CDC 515

Madame Djènè Condé, Republic of Guinea's first lady, is shown during her August 12, 2014, visit to CDC headquarters in Atlanta. Accompanied by members of the Ebola Emergency Response Team including Dr. Pierre Rollin (left), Condé was touring CDC's Emergency Operations Center (EOC) in response to the Ebola outbreak in her country. While at CDC headquarters, Condé taped a public safety announcement to be used for Ebola prevention efforts in Guinea.

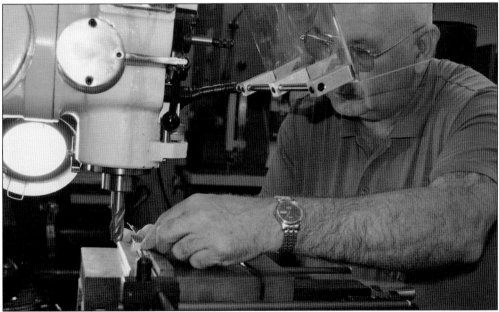

An engineering technician in CDC's Division of Applied Research and Technology (DART) is pictured at a milling machine creating a microphone mounting device. DART provides national and international leadership in research focused on the prevention of occupational illness and injury. It does this by developing and evaluating methods and tools to identify and quantify workplace hazards (chemical, physical, organizational) and finding ways to control exposure to workplace hazards.

Men, women, and children gather water from a cistern in the densely populated Shivaji Nagar settlement in India. Unsafe drinking water, inadequate sanitation, and poor hygiene are global public health threats that place people at risk for a host of diarrheal and other diseases, as well as chemical exposure. An estimated 1.1 billion people (one-sixth of the world's population) lack access to clean water, and 2.6 billion lack access to adequate sanitation. CDC interventions and clean-water technologies are helping to make safe drinking water accessible to people in developing countries. (David Snyder/CDC Foundation.)

Sprinkles, a micronutrient product, is having a huge impact in African villages where many children suffer vitamin and nutrient deficiencies due to limited diets. Introduced by CDC partner agency the Safe Water and AIDS Project (SWAP), Sprinkles vitamin packs are sold to local women who sell the packets for a small profit, helping to supplement their income. Micronutrient products contain 15 vitamins and minerals that are essential for a child's development and survival. (David Snyder/CDC Foundation.)

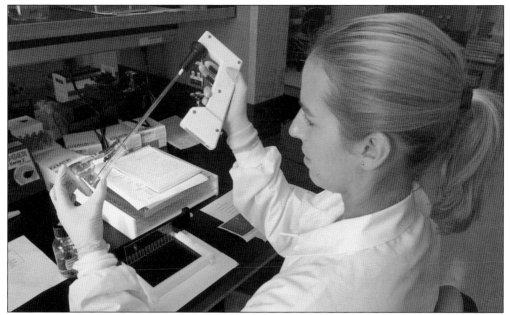

A microbiologist in CDC's Meningitis and Special Pathogens Branch (MSPB), located in the National Center for Infectious Diseases (NCID), is shown running a pulsed-field gel electrophoresis (PFGE) analytical test, which is used in the typing of bacterial organisms. The MSPB is responsible for monitoring an eclectic group of bacterial infections and disease syndromes important to public health.

A scanning electron micrograph shows a dorsal view of a tick. Ticks act as vectors for a number of arboviruses, including Lyme disease and Rocky Mountain spotted fever. CDC's Division of Vector-Borne Diseases (DVBD) helps protect the nation from bacterial and viral diseases transmitted by mosquitoes, ticks, and fleas. These diseases are becoming more of a threat to human health as the environment changes and globalization increases. DVBD houses much of the world's expertise in the diagnosis, prevention, and control of these diseases.

Tobacco use is a major preventable cause of premature death and disease worldwide. Currently, nearly six million people die each year due to tobacco-related illnesses. CDC has been waging a battle against tobacco since the 1960s. Through efforts like the Bloomberg Initiative to Reduce Tobacco Use, CDC collects data on tobacco use and control measures in countries such as Brazil, where this anti-tobacco message was displayed. Survey data are used to reduce tobacco use globally. (David Snyder/CDC Foundation.)

While malaria is no longer a major threat in the United States, a child dies from the disease every 60 seconds in Africa. However, malaria can be prevented through simple solutions like bed nets. The CDC Foundation's "Bed Nets for Children" program enables CDC teams working in Kenya and Haiti to purchase and distribute insecticide-treated bed nets to children and pregnant women who are most at risk for contracting malaria. (David Snyder/CDC Foundation.)

The National Center for HIV/AIDS, Viral Hepatitis, STD, and TB Prevention (NCHHSTP), one of the larger centers at CDC, has a budget of approximately $1 billion. NCHHSTP is responsible for public health surveillance, prevention research, and programs to prevent and control HIV infection and AIDS, other sexually transmitted diseases (STDs), viral hepatitis, and tuberculosis. Here, a researcher prepares for drug resistance testing to analyze the sequencing and fragment characteristics of a uniquely coded DNA molecule as part of AIDS research.

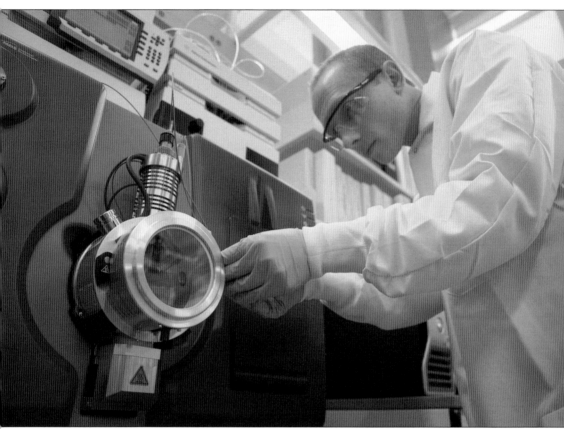

CDC's Clinical Chemistry Branch (CCB), pictured here, develops and improves methods for assessing disease status associated with and the risk for selected chronic diseases, including cardiovascular disease, diabetes, and hormonal disorders. It serves as a reference laboratory for these measurements by providing standards used as accuracy points by laboratories around the world. Ultimately, findings from these research studies are translated into clinical applications, enabling doctors to tailor treatments to their patients. (David Snyder/CDC Foundation.)

Above, an attendee poses a question at a town hall meeting sponsored by the Agency for Toxic Substances and Disease Registry (ATSDR). The purpose of these and similar meetings is to hear community concerns and share health messages about local environmental issues. CDC's Healthy Communities Program works with communities through local, state and territory, and national partnerships to establish population-based strategies to reduce chronic disease and achieve health equity. Because the United States has become increasingly diverse over the last 120 years, CDC is committed to addressing equity issues across all of its programs. According to the 2010 census, approximately 36 percent of the US population belongs to a racial or ethnic minority group. Though health indicators such as life expectancy and infant mortality have improved for most Americans (such as the two African American children pictured below), some minorities experience a disproportionate burden of preventable disease, death, and disability.

The 2011 movie *Contagion*, which fictionalized the world's emergency response to a global respiratory disease outbreak, was partially filmed at CDC headquarters in Atlanta to add authenticity to the film. CDC's work and professionals are prominently depicted by major actors in the film who race to investigate and respond to the unfolding outbreak.

This is a series of items featured in a Native Diabetes Wellness Program (NDWP) exhibit at the CDC Library. The mission of the NDWP is to work with a growing circle of partners to address the health inequities so starkly revealed by the number of people with diabetes in areas of the United States with Native American populations. NDWP uses varied methods that are respectful of local cultures and geographic diversity to organize, share data, and evaluate programs that support health practices and policies to sustain a healthier environment. NDWP supports 17 cooperative agreements in tribal communities to increase access to traditional foods, physical activity, and social support.

The Stephen B. Thacker CDC Library offers print and electronic resources on topics including disease prevention, epidemiology, infectious diseases, global health, chronic diseases, environmental health, injury prevention, and occupational safety and health. Formerly known as the CDC Library, the facility, located on the Atlanta Roybal campus, was renamed for the late Dr. Stephen Thacker in July 2014. Dr. Thacker's distinguished 37-year career at CDC embodied the best of CDC's commitment to science and public health service.

CDC's National Center for HIV AIDS, Viral Hepatitis, STD, and TB Prevention (NCHHSTP) offers activities that provide college students with opportunities to learn more about public health careers, including the summer internship program shown here. This particular program is a six- to eight-week seminar series designed to provide students with knowledge and skills in conducting public health prevention, intervention, surveillance, or epidemiologic research.

In 1978, CDC established the Newborn Screening Quality Assurance Program (NSQAP) to enhance the quality of newborn screening tests performed in the United States. Newborn screening programs test babies for disorders that are often not apparent at birth. If these disorders are not detected and treated soon after birth, they may cause developmental disabilities, severe illness, or premature death. Today, cutting-edge technology can test newborns for more diseases than ever. NSQAP, located in CDC's Environmental Health Laboratory, has become the only comprehensive program in the world devoted to quality assurance of newborn screening tests. CDC recently expanded laboratory capabilities to include a group of molecular biologists who have expertise in understanding how genetics and changes in DNA are associated with important public health issues such as diabetes, kidney disease, birth defects, and asthma. CDC is also combining its biomonitoring expertise with its newborn screening expertise to examine the possibility of using newborn screening dried blood spots to measure exposure to environmental chemicals such as pesticides and metals. (David Snyder/CDC Foundation.)

Motor vehicle crashes are a leading cause of death in the United States. More than 2.3 million adult drivers and passengers were treated in emergency departments as the result of motor vehicle crashes in 2009. CDC's research and efforts in motor vehicle injury prevention target improving booster seat and seat belt use, reducing impaired driving, and helping at-risk groups (child passengers, teenage drivers, and senior drivers).

This health care worker is attending to a newborn infant. An important element for decreasing infant mortality is the prevention of low birth weight. Early prenatal care can provide necessary information to the mother and effect changes in nutrition-related and behavioral risk factors impacting the mother and her unborn baby. CDC offers a variety of prenatal and pregnancy educational tools based on surveillance systems with data that describe prevalence and trends of nutrition, health, minority disparities, and behavioral indicators for mothers and children.

The world has truly become a global village. Millions of lives have been saved or transformed and diseases eradicated or brought under control thanks to CDC researchers, field officers, lab technicians, scientists, and "disease detective" teams working to protect each and every human. CDC's work has helped reinvent global health as we know it today, helping people of all religious, ethnic, and socioeconomic backgrounds to live longer, healthier, and better lives. CDC has successfully done this by breaking down artificial walls between scientists, eliminating redundancies, and strengthening collaboration with medical and scientific teams on a grand scale. As CDC continues to establish surveillance systems, disseminate health guidelines, implement research findings, and create effective public health programs, its work will guide and protect the world as it faces the new and complex health challenges of the 21st century.

About the David J. Sencer CDC Museum

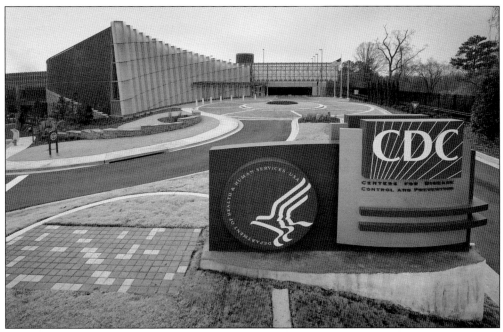

In support of the mission of CDC, the David J. Sencer CDC Museum, a Smithsonian Affiliate, is an interactive educational facility located at the entrance of CDC headquarters in Atlanta, Georgia. Designed to educate visitors about CDC, public health, and the benefits of prevention, the museum welcomes 90,000 visitors a year and provides more than 500 scheduled tours presenting CDC's rich heritage and vast accomplishments through engaging museum exhibitions and dynamic educational programming. CDC Museum visitors view award-winning media presentations, as well as innovative temporary and permanent exhibits that demonstrate how CDC serves people throughout the world. Current and former CDC employees serve as tour guides and provide insight into the day-to-day work of the agency. Ongoing educational and outreach efforts use curriculum-based, onsite educational programs targeting middle- and high-school students.

Admission and parking are free, and no reservations are required. For more information, visit http://www.cdc.gov/museum.

DISCOVER THOUSANDS OF LOCAL HISTORY BOOKS FEATURING MILLIONS OF VINTAGE IMAGES

Arcadia Publishing, the leading local history publisher in the United States, is committed to making history accessible and meaningful through publishing books that celebrate and preserve the heritage of America's people and places.

Find more books like this at
www.arcadiapublishing.com

Search for your hometown history, your old stomping grounds, and even your favorite sports team.